NO ONE TOLD ME NOT TO DO THIS

NO ONE NOT TO

SELECTED SCREENPRINTS
2009 — 2015

FOREWORD by AARON HORKEY

TOLD ME DO THIS

JAY RYAN

Published by Akashic Books
©2016 Jay Ryan

Book design by Jason Harvey
Photography by Nathan Keay except where noted otherwise

ISBN: 978-1-61775-495-1
Library of Congress Control Number: 2016903671

Printed in Korea

Akashic Books
Twitter: @AkashicBooks
Facebook: AkashicBooks
E-mail: info@akashicbooks.com
Website: www.akashicbooks.com

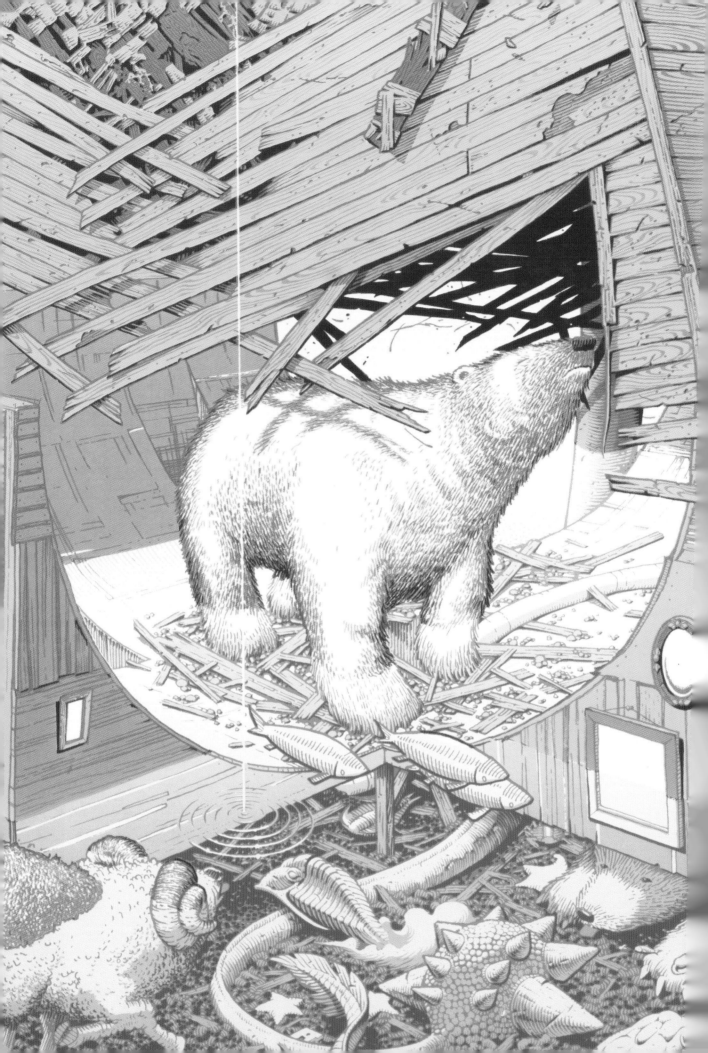

Foreword by Aaron Horkey

As with most fairy tales, it all began with an over-sized Pholidota.

The year was 2010. I wasn't quite sure what to expect as I touched the highway bound for the blustery, late-spring shores of Lake Michigan with little more than a crude sketch of a pangolin in tow. Within days I'd be embarking on an analog screenprint collaboration with the incomparable Jay Ryan, a gentle giant of a man I'd met up with a handful of times over the preceding years. We had become fast friends, staying in contact via scattered correspondence, but this was to be our first time working together. On one hand we traded in complementary themes and touchstones within our respective bodies of work—animals (extinct, extant, and imaginary), unreal narratives, and the muted Midwestern palette of our shared native habitat. On the other hand, Jay's lively, playful compositions stood in stark contrast to the dense and obsessive web of lines I cover every square inch of my pictures with. The offspring of this meeting could result in a beautiful wet fawn or a smoldering stillborn husk—there really wasn't much of a middle ground between those two extremes with which to land our ship.

Luckily, any lingering pangs of nervousness I may have been harboring soon dissipated as I entered the welcoming walls of the Bird Machine, Jay's print shop in charming Skokie, Illinois. We very quickly fell into a comfortable groove of intricate Rubylith cutting, Kimoto Pake pen rendering, on-press ink mixing, and frenzied printing that eventually culminated in the twenty-five-color landscape of impassioned Technicolor dust-kicking entitled *Versus*.

Along the way we broke exposure-unit glass, reshot key plate screens, soaked up Aphex Twin videos, falafels, and cereal, overdosed on Editors and Future of the Left records, printed tiny hot-pink brontotherium tongues, and tended to a bumper crop of hens and chicks, only taking breaks for back-alley no-complies and runs to the fossil store. I had my brain broken open to a whole new method of madness which changed my entire approach to making prints. It was on *Versus* that I first dipped my toe into the black-lake method of "dark shadows" post–key plate dimensional building that dramatically filled out my printmaking quiver. These sessions were also some of the most fun I've ever had while working—a fantastic experience front to back and one which I'll never forget.

In the years since we've collaborated on three other prints, all of which appear in this, the third volume of Jay's collected works. I'm very much looking forward to breaking in a new blade on number five—all signs point to it kicking like a sleep twitch.

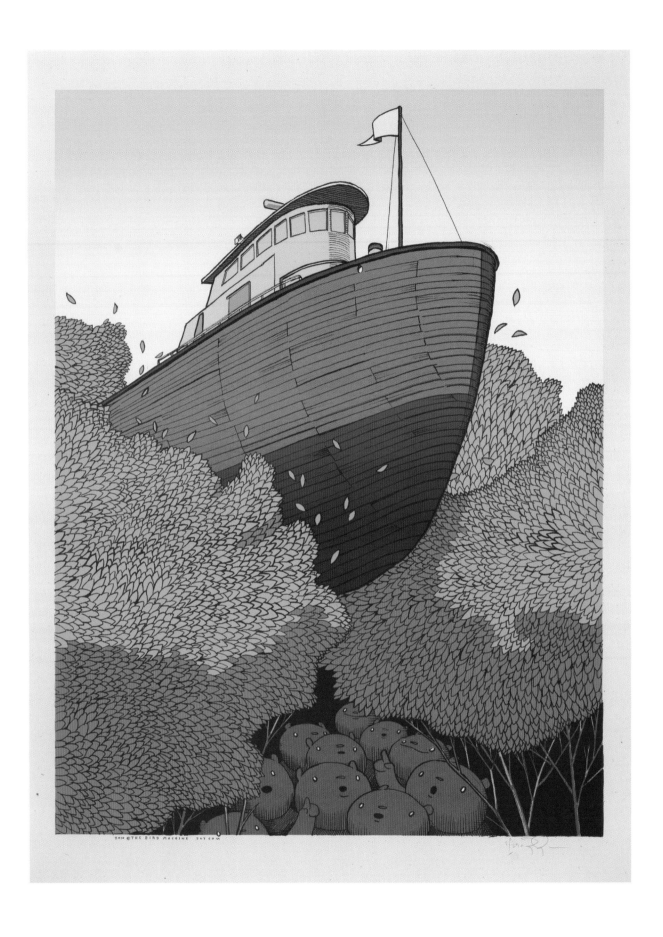

The Stib (opposite)
2010
Seven screens
18 x 24 inches

**Chicago Underground
Film Festival**
2010
Five screens
18 x 24 inches

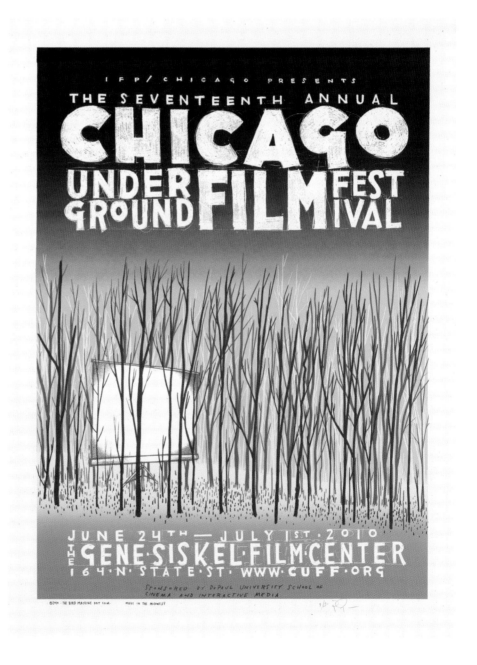

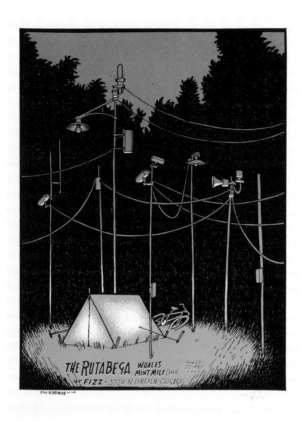

The Rutabega, with Whales and Mint Mile
2015
Three screens
18 x 24 inches

Made as we were all heading into a summer full of weekend camping trips. The lights don't work.

Screens and Spokes (opposite)
Collaboration with Dan McCarthy
2010
Four screens
18 x 24 inches

I finally got to work with one of my favorites, Dan McCarthy, for this print made for an annual art/bicycle event which raises money for multiple sclerosis research. Dan makes a lot of forest scenes and I make a lot of animals on bikes, so I don't think we caught anyone off guard with the subject of this print.

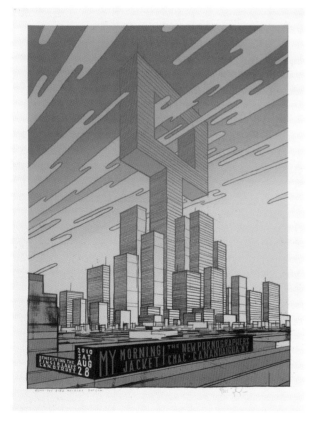

My Morning Jacket in Canandaigua
2010
Seven screens
18 x 24 inches

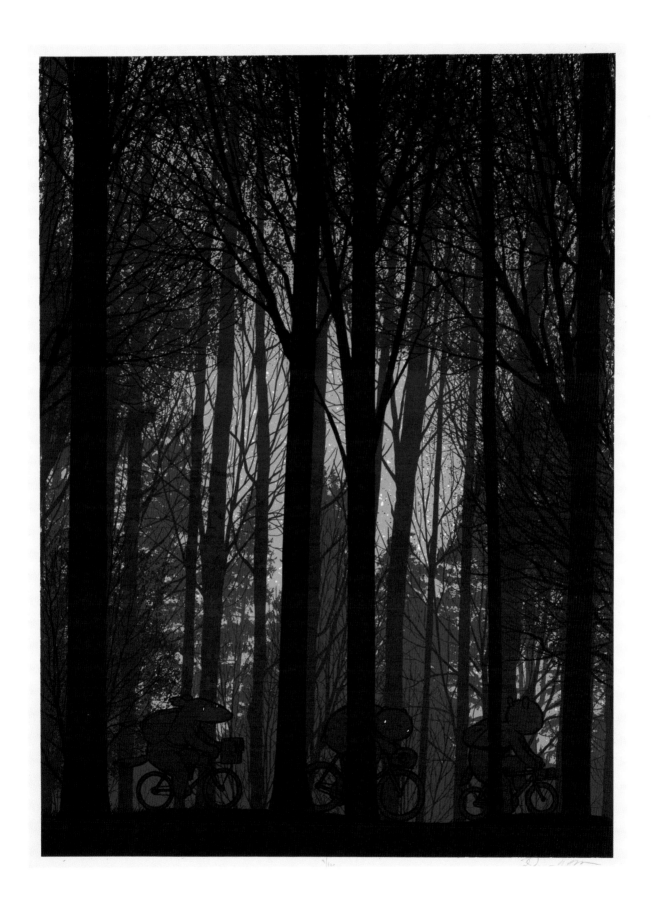

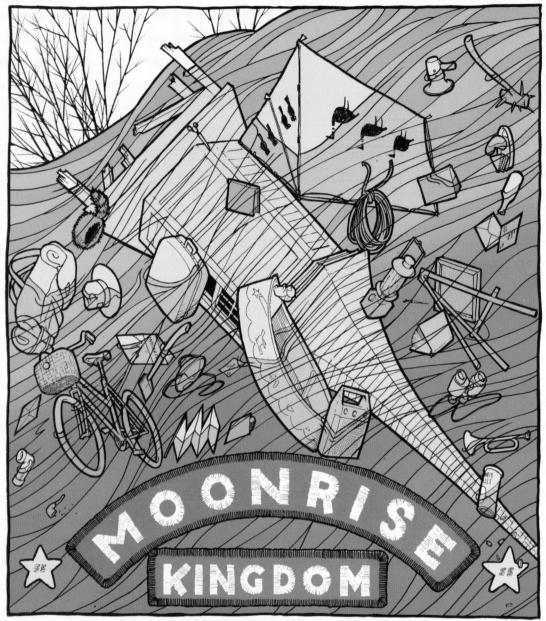

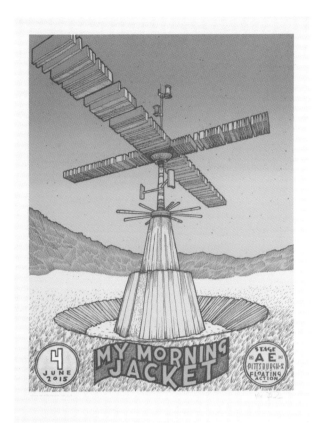

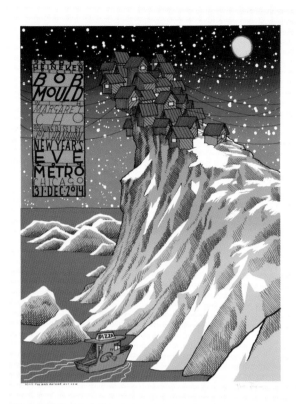

**My Morning Jacket
in Pittsburgh (above)**
2015
Five screens
18 x 24 inches

Made soon after seeing *Mad
Max: Fury Road*. I was thinking
of monumental desert
structures. I was thinking
about moisture vaporators. I
was thinking about waterfalls.

***Moonrise Kingdom*
(opposite)**
2013
Six screens
18 x 24 inches

Commissioned for Mondo's
Oscar Night collection.

**Bob Mould, New Year's
Eve (top right)**
2014
Six screens
18 x 24 inches

As remote as we may try to be,
we're still connected enough to
get pizza delivered by boat.

**Japandroids at
Sasquatch! Music
Festival (right)**
2013
Four screens
18 x 24 inches

MAY 24, 2013 / SASQUATCH! MUSIC FESTIVAL / THE GORGE / WA

**Andrew Bird & the Hands
of Glory**
2014
Four screens
18 x 24 inches

Another appearance by the
Giant of Illinois.

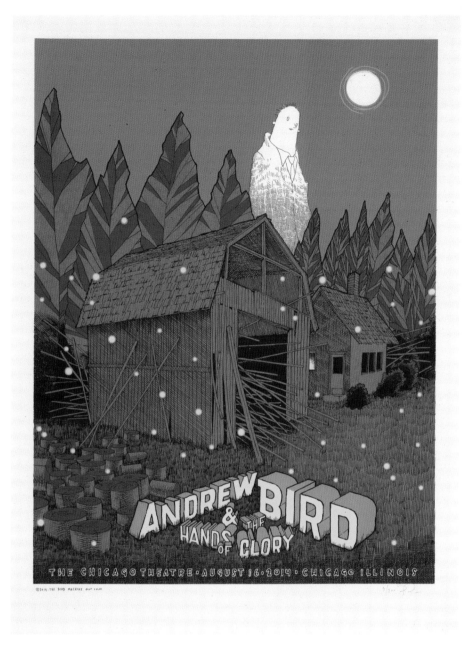

Hum in Austin
2011
Four screens
18 x 24 inches

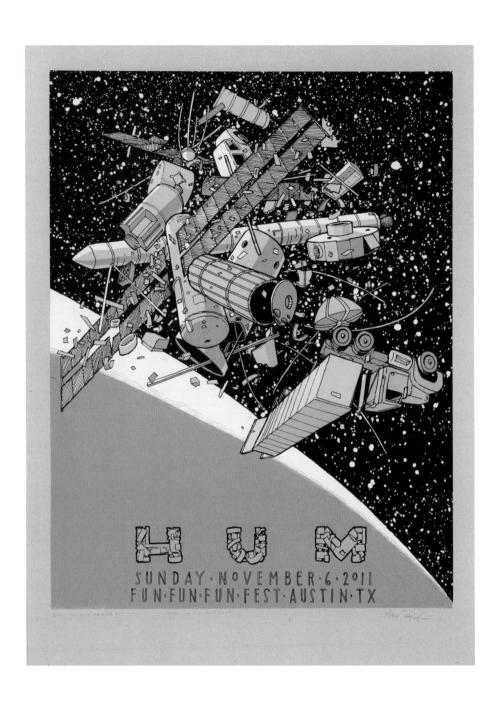

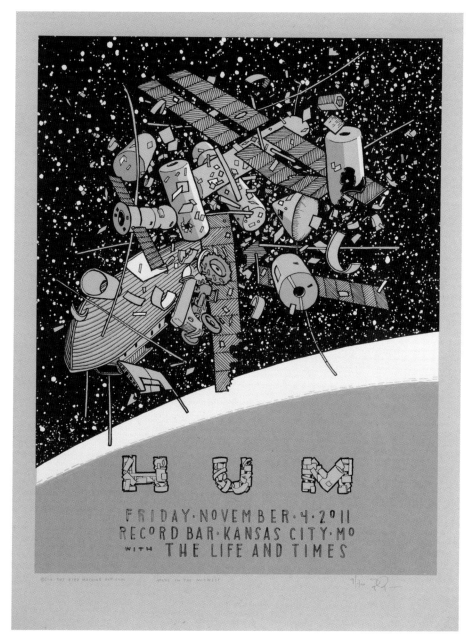

Hum in Kansas City
2011
Four screens
18 x 24 inches

The tractor depicted here belongs to my brother, who lives near Kansas City.

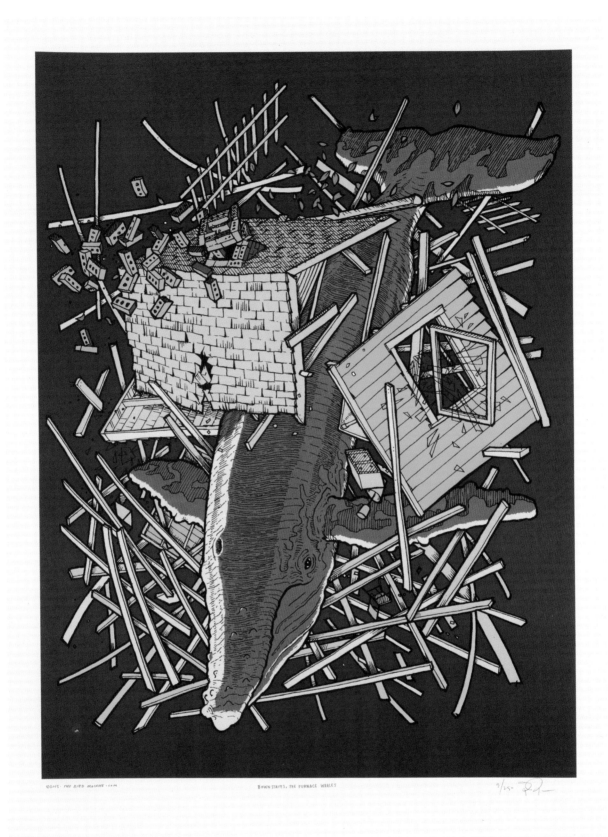

DOWNSTAIRS, THE FURNACE WHALES

9/250

Downstairs, the Furnace Whales (opposite)
2015
Eight screens
18 x 24 inches

In January 2015, my family hid away in a cabin in northern Indiana that predates the Civil War. This little house had no level floors and no right angles, and I sat drawing at the table while listening to Neko Case sing "Stinging Velvet"— deliberately mishearing a lyric about the furnace.

Coronal Mass Ejection (bottom)
2011
Nine screens
18 x 24 inches

In 2011, Tommy Quinn commissioned a print for his Apocalypse Calendar project in anticipation of the end of the world, which had been scheduled for 2012. A dozen illustrators submitted different scenarios for how the world would end in 2012, and this was mine, with the sun gently washing away the useful parts of Earth's atmosphere, and removing the roofs from our garages.

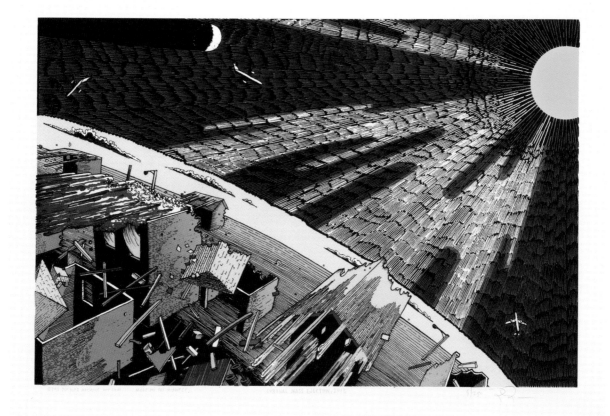

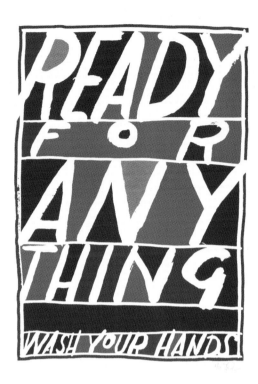

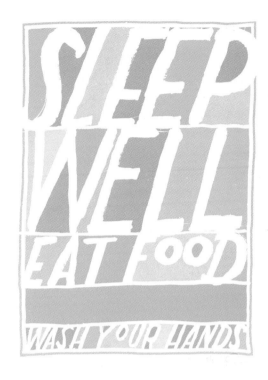

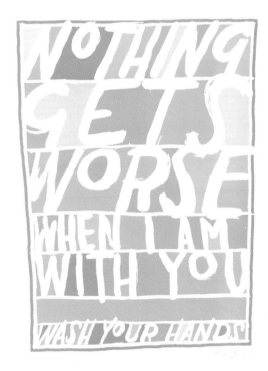

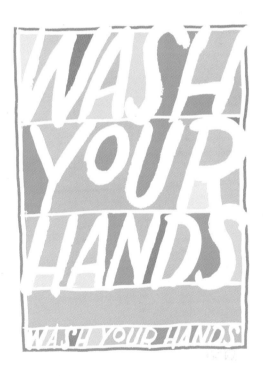

**Wash Your Hands
(opposite)**
2014
Set of four prints
Three screens each
11 x 14 inches

According to photos e-mailed
to me, these four prints are
framed in various bathrooms
around the world.

Let's Tape
2012
Three screens
18 x 24 inches

A public service announcement
promoting the use of adhesives.

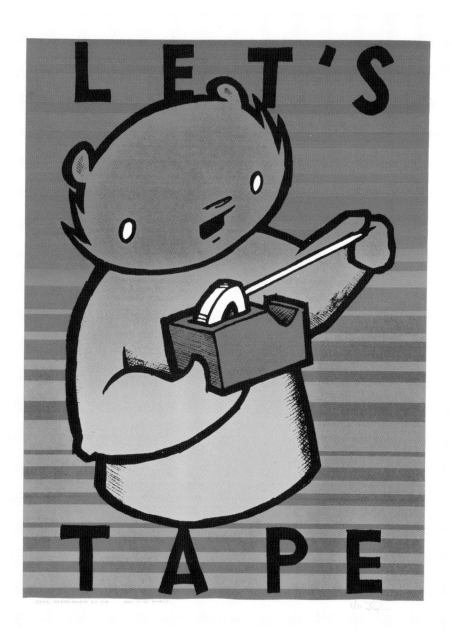

Deer Sanctuary
2010
Six screens
18 x 24 inches

I find great reward in depicting mammals stuffed up into trees, especially as a way to avoid hunting season.

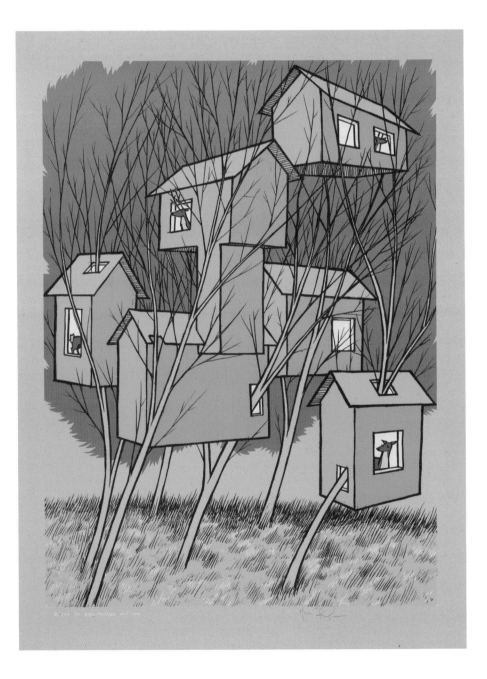

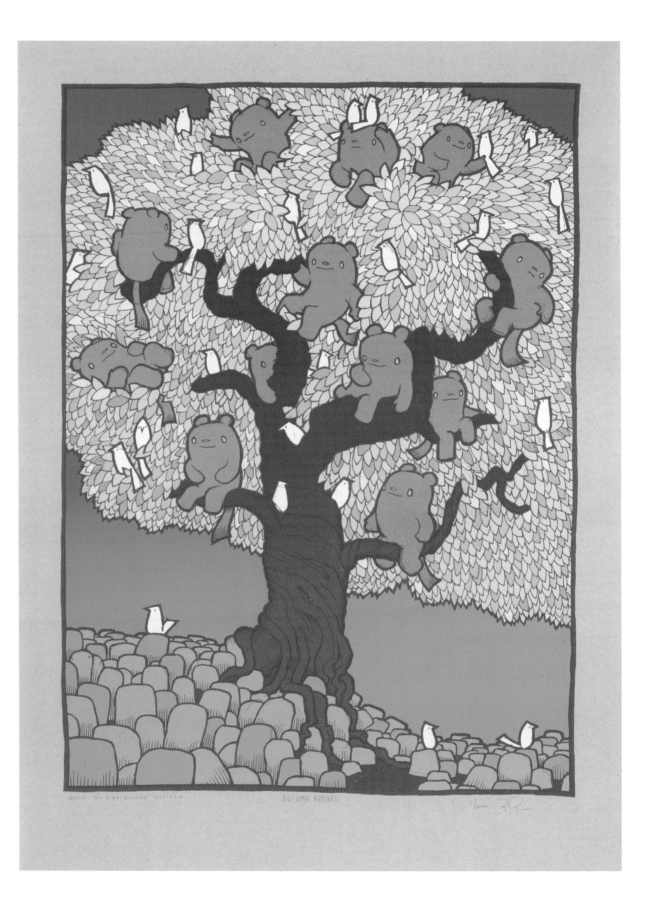

Autumn Arrives (opposite)
2013
Six screens
18 x 24 inches

More mammals stuffed
up into trees, echoing the
Intercontinental print
from 2007.

Progeniture
2012
Six screens
18 x 24 inches

This was made to celebrate the
twentieth anniversary of Chica-
go's Thrill Jockey record label.
A mother mammal watches over
her young.

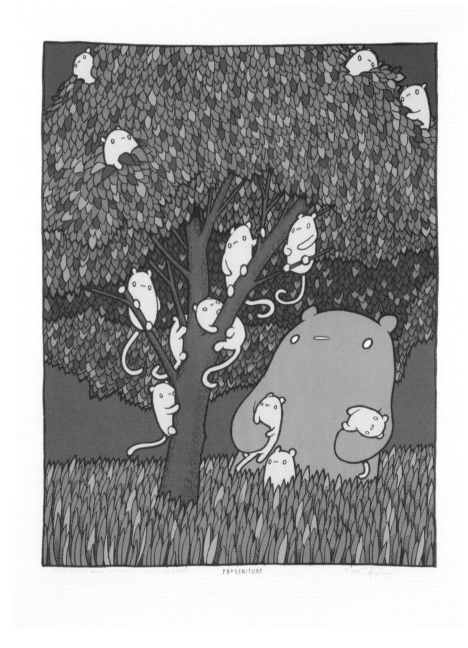

PROGENITURE

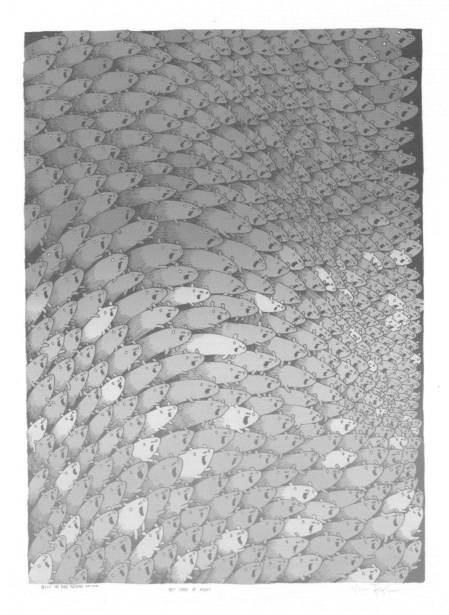

They Sang at Night
2011
Four screens
18 x 24 inches

In 2011, I was in Hamburg, Germany late one evening when I came upon a painted wall depicting what I believe were bananas (see below). When I got home, I tried to recreate the image, but the bananas turned out to be these little nocturnal lemming guys, and they all appeared to be singing as they careened through the night sky. Later, I posted a photo of this finished print on social media, and within minutes my friend Michael Vivian (in Perth, Australia) commented, "470." I was momentarily confused, but quickly had my assistant count the animals on the print, and the actual quantity was 473. Pretty good counting skills for a small jpg file on social media. Pretty good counting skills for an Australian math teacher who was looking at the image upside down.

The Gatherer (opposite)
2012
Six screens
18 x 24 inches

Another take on the texture used in *They Sang at Night*, this time anticipating a robust year in the garden.

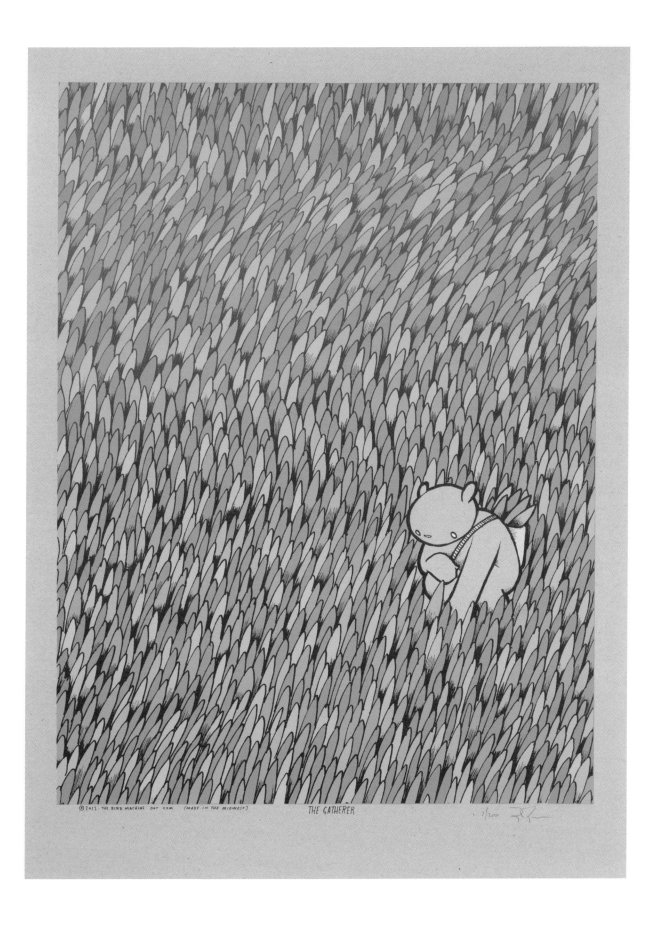

THE GATHERER

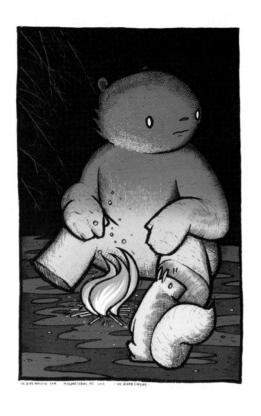

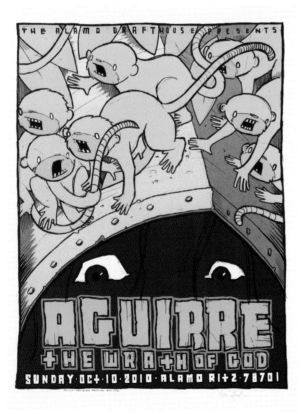

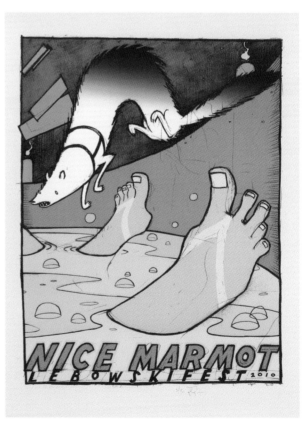

**We Heard Singing
(opposite, top left)**
2012
Six screens
12.5 x 19 inches

Soon after making *They Sang at Night,* I was teaching screen-printing at Penland School of Crafts in the mountains of North Carolina, and made this companion piece.

**North from the Pines
(opposite, top right)**
2014
Six screens
12.5 x 19 inches

I returned to Penland School of Crafts in 2014, and this was the print I completed while teaching in the school's amazing print studio. The Pines is the name of the dining hall, and to get to the printmaking studio, you head . . . well, northeast. The north side of the Pines is where the excellent coffee shop is. Maybe that's what I was thinking.

**Aguirre, the Wrath of God
(opposite, bottom left)**
2010
Five screens
18 x 24 inches

One of my favorite films, Werner Herzog's *Aguirre*, starring Klaus Kinski, screening at the Alamo Drafthouse Cinema in Austin.

Nice Marmot (opposite, bottom right)
2010
Six screens
18 x 24 inches

Commissioned by Lebowski Fest, the more-or-less annual traveling celebration of the Coen Brothers' cinematic masterpiece.

The Breeders LSXX
(second edition)
2013
Four screens
18 x 24 inches

The band commissioned these prints for a summer tour celebrating the twentieth anniversary of the landmark *Last Splash* album. I based the poster on the Vaughan Oliver album cover, but tried to find what the image would look like twenty years later, having had time to settle and take root, yet remain vibrant.

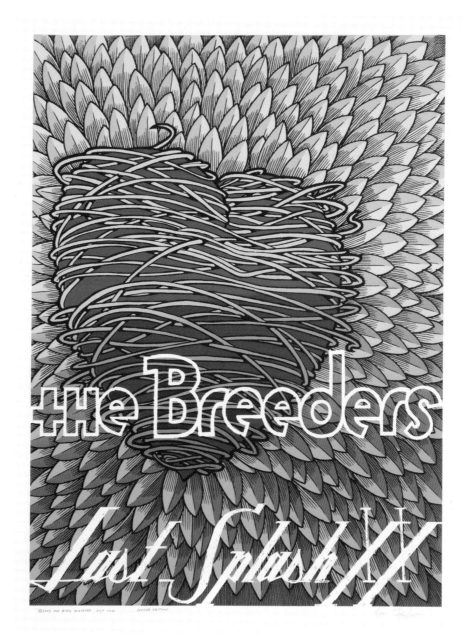

Peter Hook & The Light
2011
Seven screens
18 x 24 inches

One of my favorite musicians, and a definite inspiration on my own bass playing, Peter Hook formed a new band, The Light, to perform Joy Division's *Closer* album in Manchester. I didn't want to ape the cover of the album, but tried to get the feel of the earliest New Order sleeves, and felt like this worked.

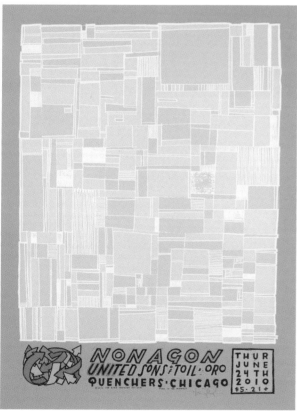

PRF BBQ (top left)
2014
Five screens
18 x 24 inches

A community of my friends,
most of whom play in bands,
organize an annual event where
all of our bands play to each
other. We live like damn
hell-ass kings.

Sonic Youth (top right)
2009
Seven screens
20 x 26 inches

Loosely based on a
Lee Bontecou form.

**Nonagon
(bottom left)**
2010
Seven screens
18 x 24 inches

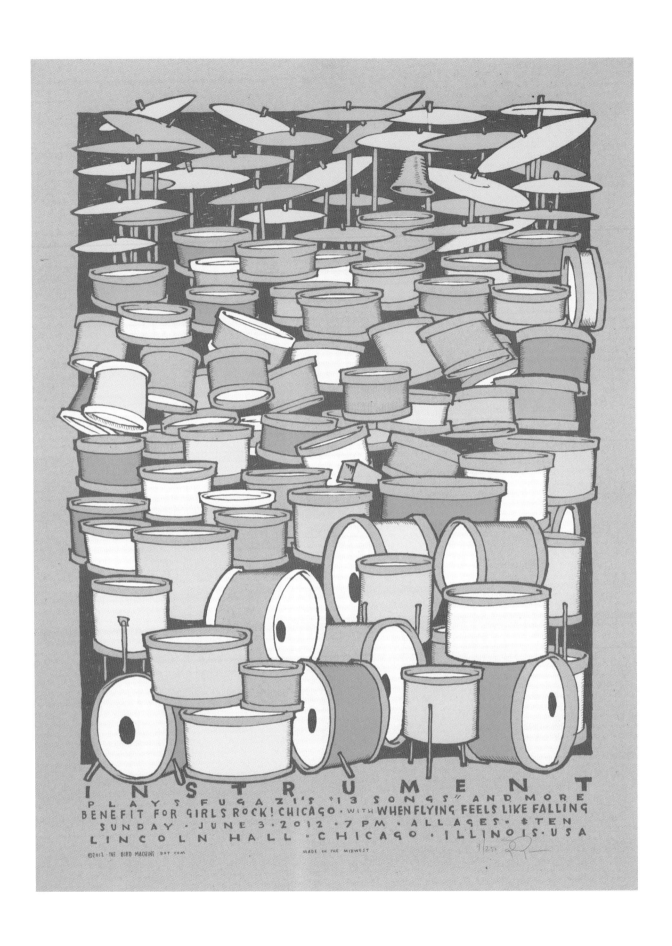

Instrument (opposite)
2012
Four screens
18 x 24 inches

I played bass in a short-lived
cover band called Instrument,
and we performed Fugazi's *13
Songs* record, as well as some
other Fugazi favorites, at a
benefit concert to raise money
for the Girls Rock! Chicago
music program. The goal was to
raise enough money to buy the
program twenty new drum sets.

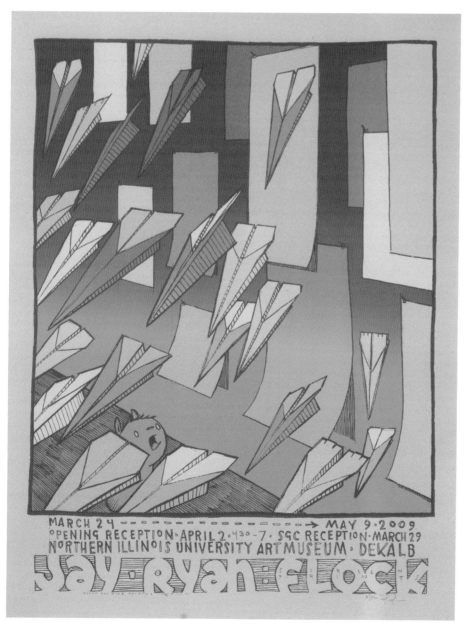

Jay Ryan / Flock
2009
Five screens
20 x 26 inches

The curator at Northern Illinois
University named this show of
my prints at the school's gallery.

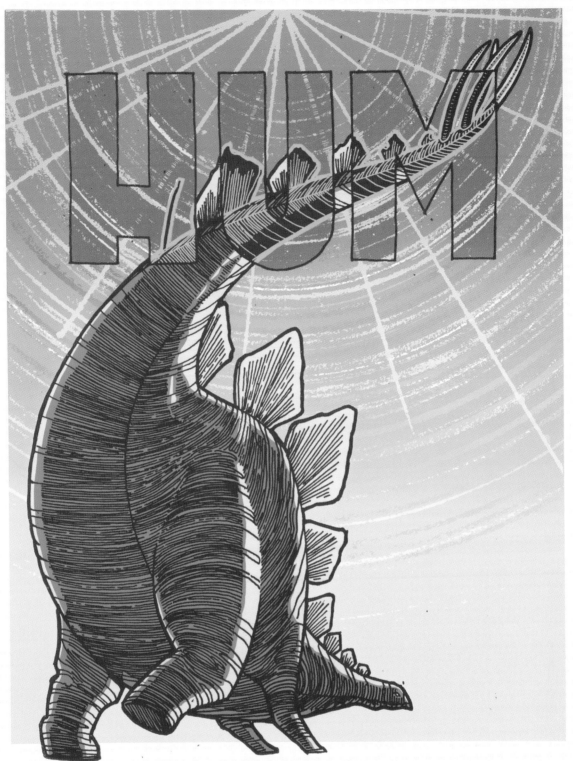

FRIDAY · SEPTEMBER 9 · HIGHDIVE · CHAMPAIGN · W/ DIBIASE

© 2011 · THE BIRD MACHINE DOT COM MADE IN THE MIDWEST

**Hum in Champaign
(opposite)**
2011
Seven screens
18 x 24 inches

**Hum at A.V. Fest Chicago
(right)**
2011
Seven screens
18 x 24 inches

Both prints in this diptych have
overlapping split fountains in
the background.

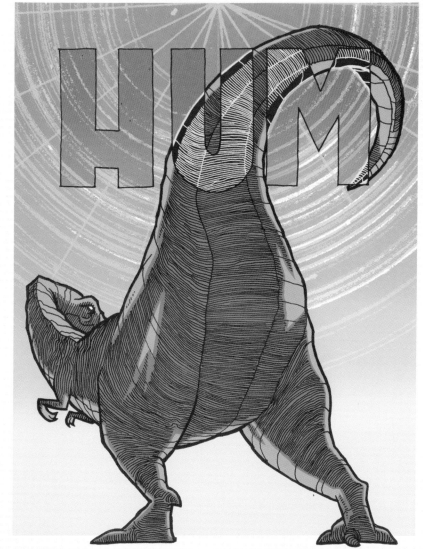

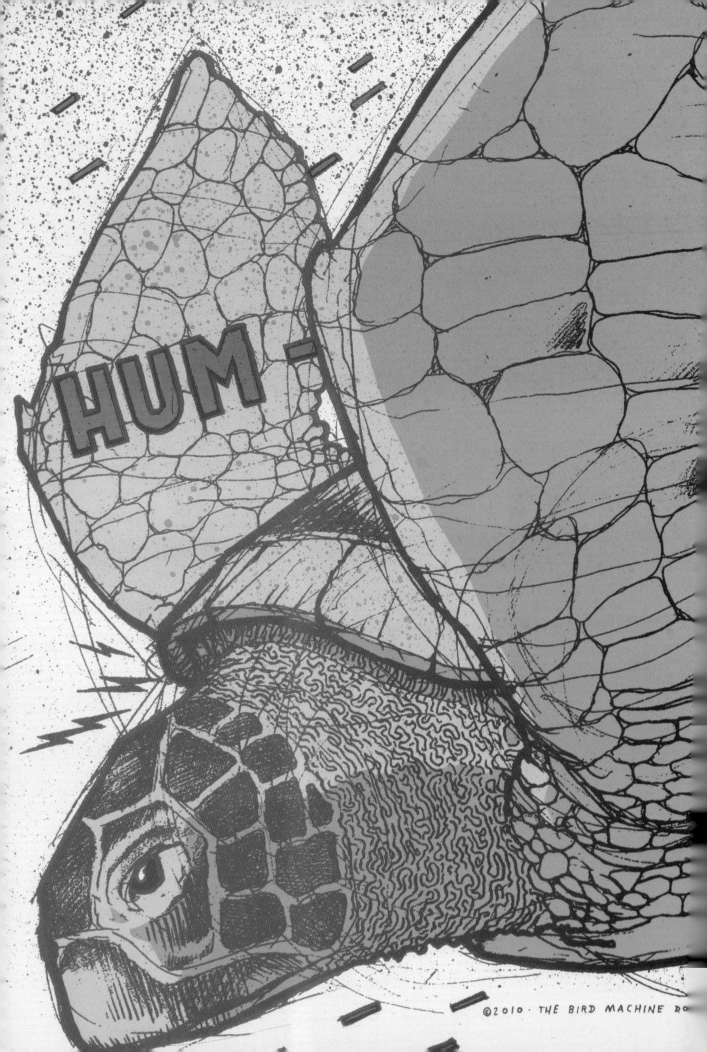

Hum at Millennium Park
2010
Four screens
18 x 24 inches

During the BP Gulf oil spill
of 2010.

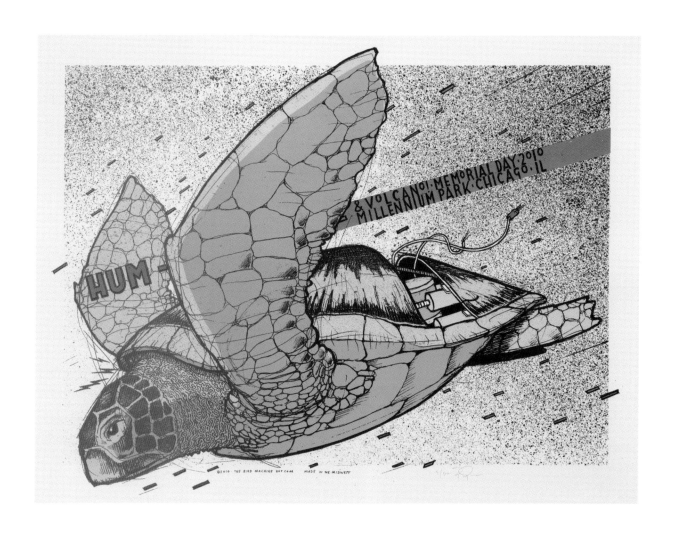

The Jesus Lizard
New Year's Eve (opposite)
2009
Five screens
18 x 24 inches

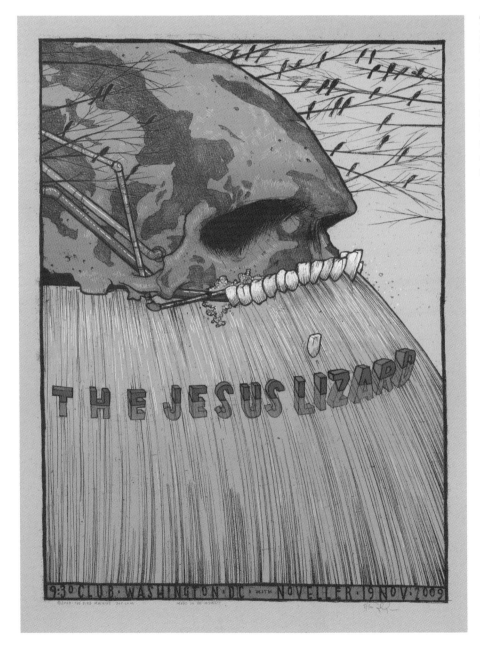

The Jesus Lizard in DC
2009
Six screens
18 x 24 inches

I glanced at the cover of a Patagonia clothing catalog and entirely misinterpreted the image of some rock climbers in a hut on a bare patch of rock as a human skull. Drew the human skull I had imagined seeing.

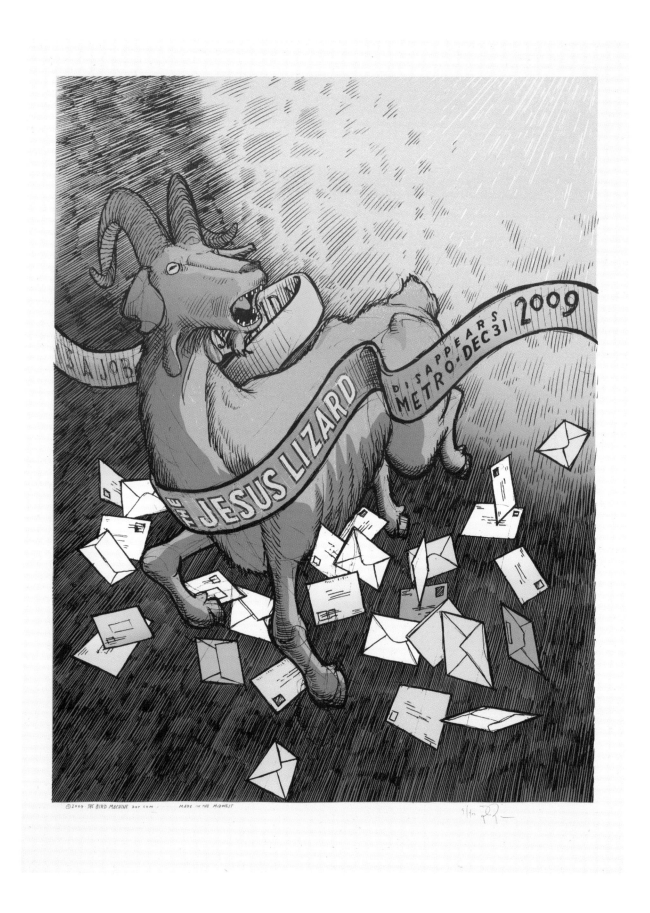

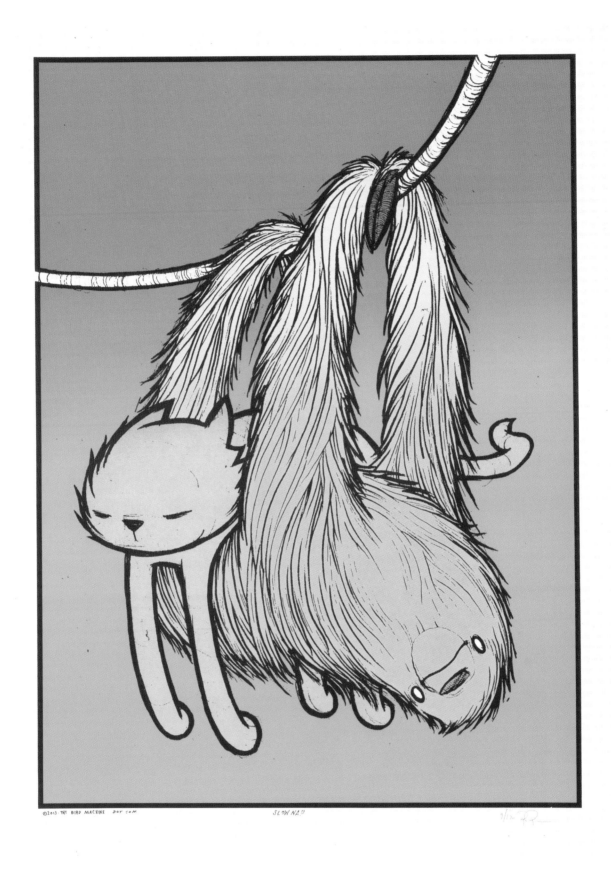

©2013 THE BIRD MACHINE DOT COM SLOW NAP

Slow Nap (opposite)
2013
Three screens
18 x 24 inches

Two of the best nappers settling in for a long one.

Big Stunts
2012
Four screens
18 x 24 inches

Originally drawn for a print demonstration at the Evanston Art Center, this needed a proper edition at full size. Includes one leftover platypus from the Shellac Australian tour poster made right around the same time.

Tub Chum
2014
Four screens
18 x 24 inches

The speckling on the bear is from spray-painting the films. Also: photobomb donut.

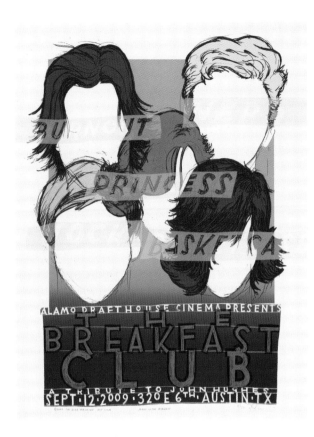

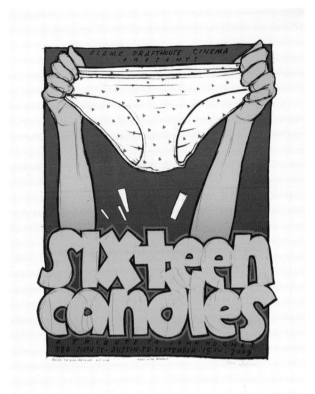

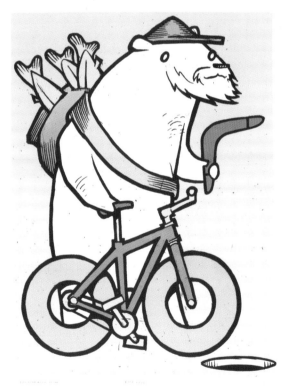

The Breakfast Club (top left)
2009
Five screens
20 x 26 inches

Print for a screening at the
Alamo Drafthouse Cinema
in Austin.

Good Haul (bottom left)
2015
Four screens
18 x 24 inches

This polar bear and his fat-
tired bike started as an earlier
version of "Polar Bike," but
the drawing sat unfinished for
several months before I realized
what he is actually doing—ice
fishing with a boomerang.

Sixteen Candles (top right)
2009
Four screens
20 x 26 inches

For a screening of John
Hughes's classic film about
being overlooked by one's fam-
ily, and/or a story about taking
drugs on one's wedding day.

The Buffalo (opposite)
2014
Four screens
18 x 24 inches

This print was made for the
ARTCRANK series of bike-
themed poster shows. Text at
the bottom of the print reads:
*World Bicycle Relief designs,
manufactures, locally assem-
bles, and distributes rugged
bicycles to students, healthcare
workers, and farmers in the
developing world. Since 2005,
WBR has distributed more
than 190,000 Buffalo Bicycles
and trained over 900 bicycle
mechanics. Buffalo Bicycles
are specifically engineered to
transport heavy loads over chal-
lenging terrain and are designed
to be compatible with locally
available spare parts.*

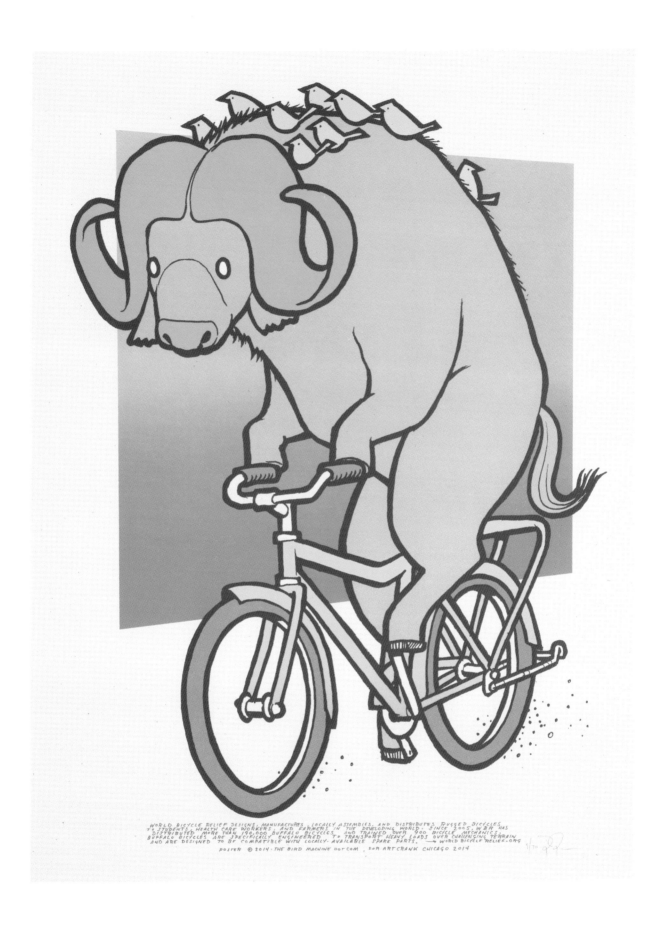

WORLD BICYCLE RELIEF DESIGNS, MANUFACTURES, LOCALLY ASSEMBLES, AND DISTRIBUTES RUGGED BICYCLES TO STUDENTS, HEALTH CARE WORKERS, AND FARMERS IN THE DEVELOPING WORLD. SINCE 2005, WBR HAS DISTRIBUTED MORE THAN 190,000 BUFFALO BICYCLES AND TRAINED OVER 900 BICYCLE MECHANICS. BUFFALO BICYCLES ARE SPECIFICALLY ENGINEERED TO TRANSPORT HEAVY LOADS OVER CHALLENGING TERRAIN AND ARE DESIGNED TO BE COMPATIBLE WITH LOCALLY AVAILABLE SPARE PARTS. → WORLD BICYCLE RELIEF.ORG

POSTER © 2014 · THE BIRD MACHINE DOT COM , FOR ARTCRANK CHICAGO 2014

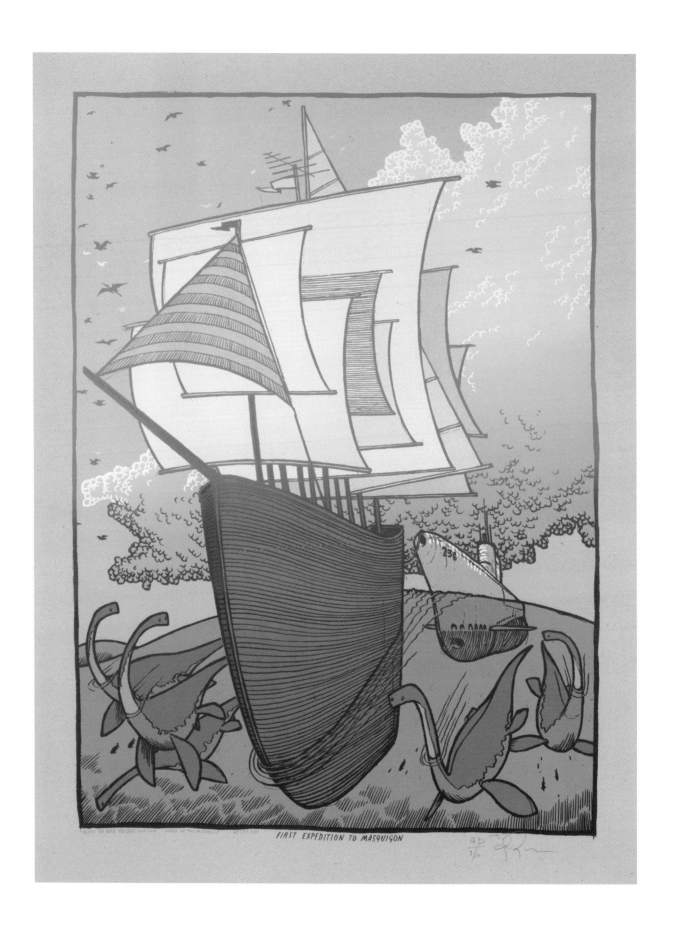

FIRST EXPEDITION TO MASQUIGON

**First Expedition to
Masquigon (opposite)**
2011
Nine screens
18 x 24 inches

A private commission by a
graphic arts group based in
Muskegon. This historically
accurate print depicts the initial
landing of Europeans along the
shores of western Michigan,
featuring all the facts I could
recall from passing through the
area as a youth in the 1980s,
including the arrival of the
USS *Silversides* from Chicago's
Navy Pier.

High Tide at White Lake
2012
Five screens
18 x 24 inches

When I was young, my family
would sometimes spend a week
or two of summer vacation in a
little cabin near White Lake, in
Michigan. My friend from the
next cabin over taught sailing
lessons in a Sunfish, which
is a small sailboat the size of
a bathtub, or coffin. I like to
believe that I am a reasonably
adventurous fellow, but I have
never really liked sailing, as I
can't get the physics of sailing
into the wind (as opposed to
the way I can easily com-
prehend my skateboard, for
example), so I used to spend a
decent amount of time in the
water next to the overturned
boat. In the subsequent thirty
years, White Lake has been
tamed and is now a nice place
to visit, but back then the
waves were ridiculous and
it was a treacherous body of
water. John Otterbacher has
been making a documentary
film about posters, and we
realized we shared some history
at White Lake. This print was
commissioned to try to help
cover his production costs,
and accurately depicts a real-
-life situation for those who
were willing to climb into a
Sunfish in the early 1980s in
western Michigan.

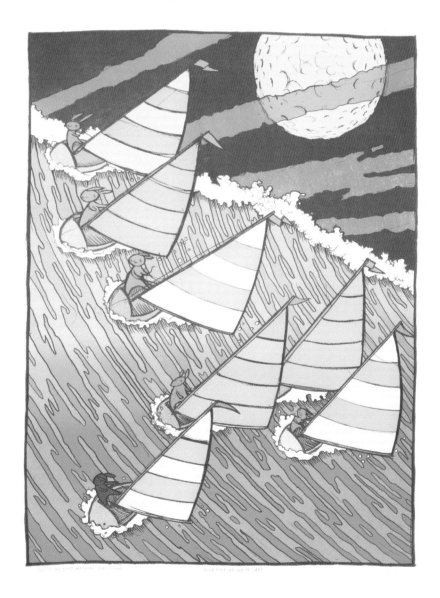

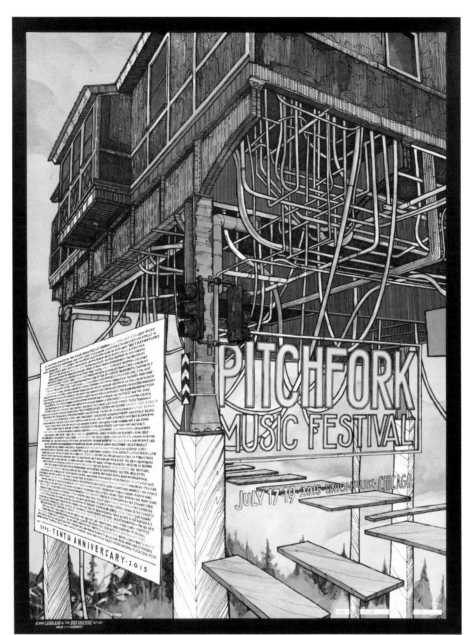

Pitchfork Music Festival
Collaboration with Landland
2015
Four screens
18 x 24 inches

Printed at Landland. Pitchfork Music Festival happened for the tenth year in a row at Union Park in Chicago, immediately south of the CTA Green Line train station at Ashland, which Dan Black (of Landland) suggested as the subject of our collaborative print. I learned a huge amount about the practical application of CMYK screenprinting from this project, and enjoyed the manic pace at which these prints were made. Dan drew the upper portions of the train station, while I was responsible for most of the underside—tubes, pipes, and pylons. I also wrote out the names of every band to have played this festival over ten years. Dan's coconspirator, Jessica Seamans, was responsible for all of the color, save the background sky, which came from a watercolor by Diana Sudyka.

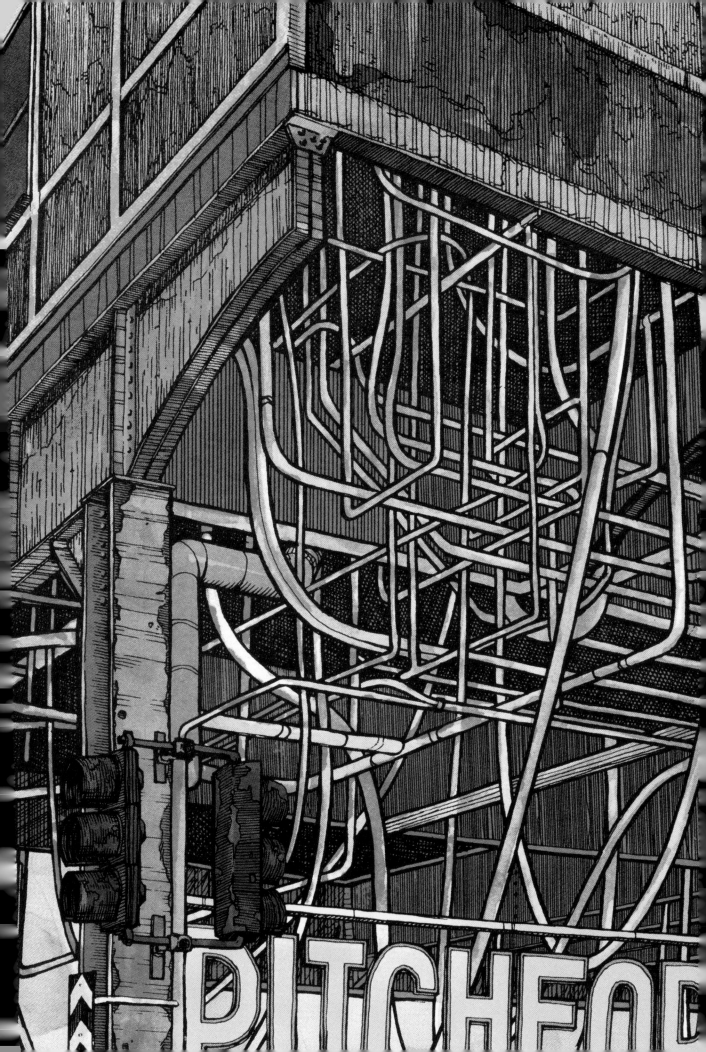

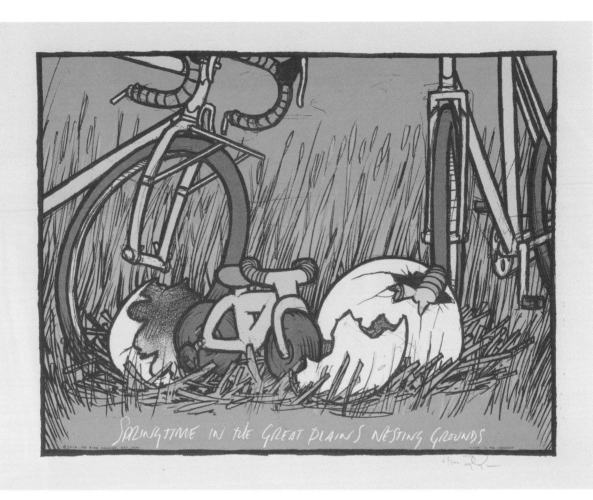

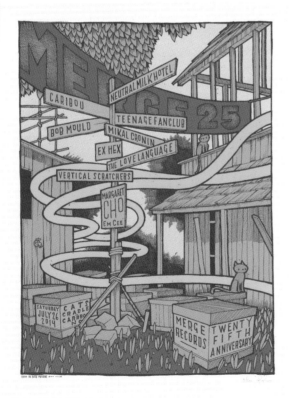

**Springtime in the Great
Plains Nesting Grounds
(top)**
2010
Four screens
18 x 24 inches

**Merge Records 25th
Anniversary (left)**
2014
Five screens
18 x 24 inches

**Andrew Bird's
Gezelligheid
(opposite)**
2015
Four screens
18 x 24 inches

The art direction I received for
this poster asked for something
which reflected the venue, a
large Gothic Revival church
right in the heart of Chicago,
across the street from the Water
Tower and the John Hancock
building. Stained glass was
suggested, but I was drawn to a
photo by Zoran Orlic of Andrew
playing last year's event, which
I ended up using for reference.
The horns, which are central
to this image, were built by Ian
Schneller here in Chicago.

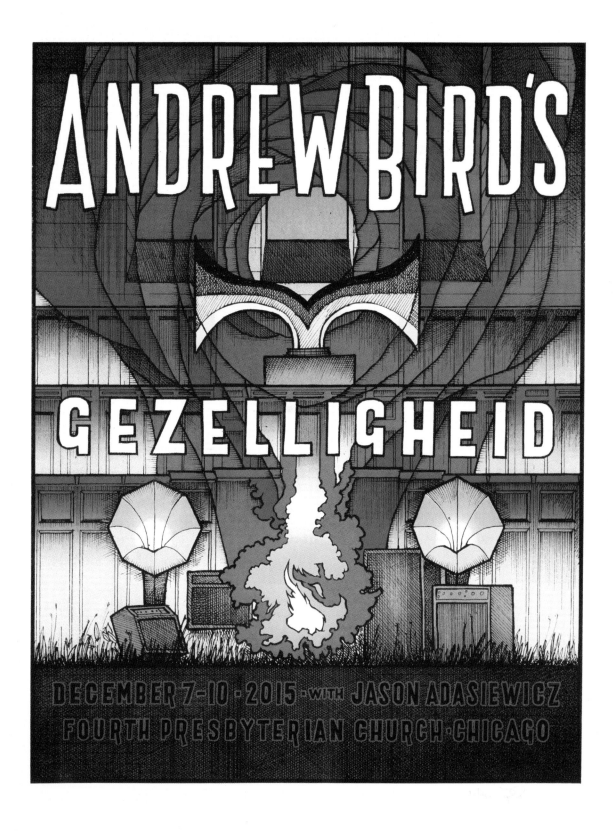

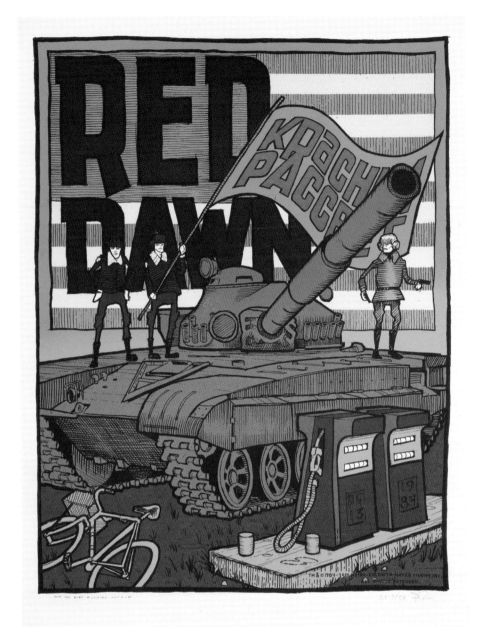

Red Dawn
2014
Six screens
18 x 24 inches

Produced in association with Mondo; licensed through MGM Studios. When doing posters through Mondo for older films, it always seems like there's a really obvious scene to recreate on a poster, so I try hard to avoid using that scene and find another memorable but less obvious one. I watched *Red Dawn* about five times leading up to this print, trying to pick the right scene, and finally decided on the Russian tank coming in to the gas station [SPOILER ALERT] just before Toni blows it up with a bomb hidden in a bicycle basket.

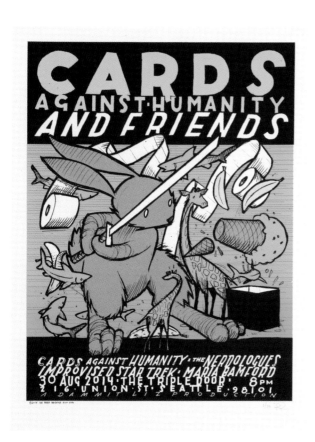

Cards Against Humanity and Friends
2014
Four screens
18 x 24 inches

A challenging job, in that the excellent folks who make the Cards Against Humanity gave me an absurd list of new cards they were working on, and I tried to include a couple of their ideas in this print, which had no other cohesive narrative. Somehow it still managed to be appropriate for the event.

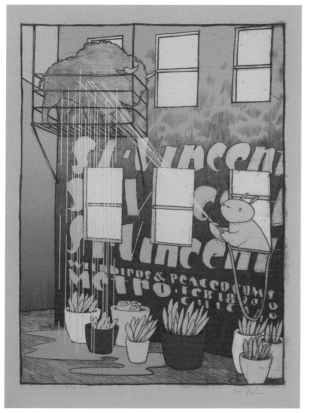

St. Vincent
2010
Six screens
18 x 24 inches

Blindly running with a misunderstood lyric about a second-floor fire escape.

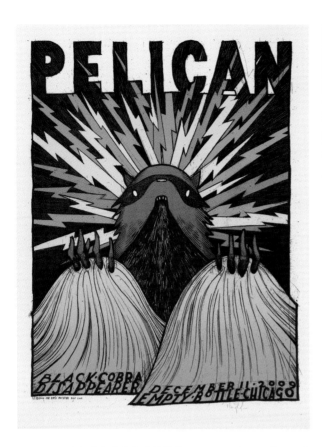

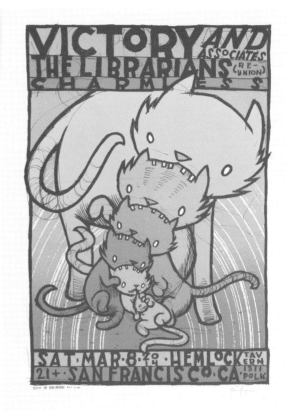

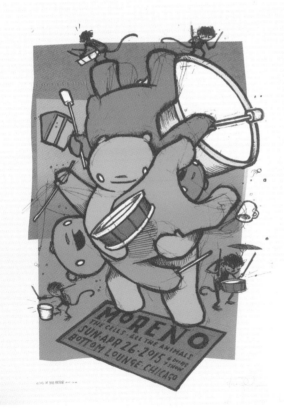

Pelican (top left)
2009
Four screens
18 x 24 inches

Very few people are aware
that the god of flowing waters
normally takes the form of a
raccoon. Now you know.

Moreno (bottom left)
2015
Four screens
18 x 24 inches

This print has four tiny
monkeys with drums, as
is appropriate.

Victory and Associates
(top right)
2014
Four screens
18 x 24 inches

Image loosely based on
Victory and Associates' new
album cover.

Pavement at Sasquatch!
Music Festival (opposite)
2010
Fifteen screens
18 x 24 inches

Pavement reunited after
being broken up for about a
decade. I treated the different
compartments of this print
as separate posters with
different colors, and made
literal references to several
of the band's lyrics.

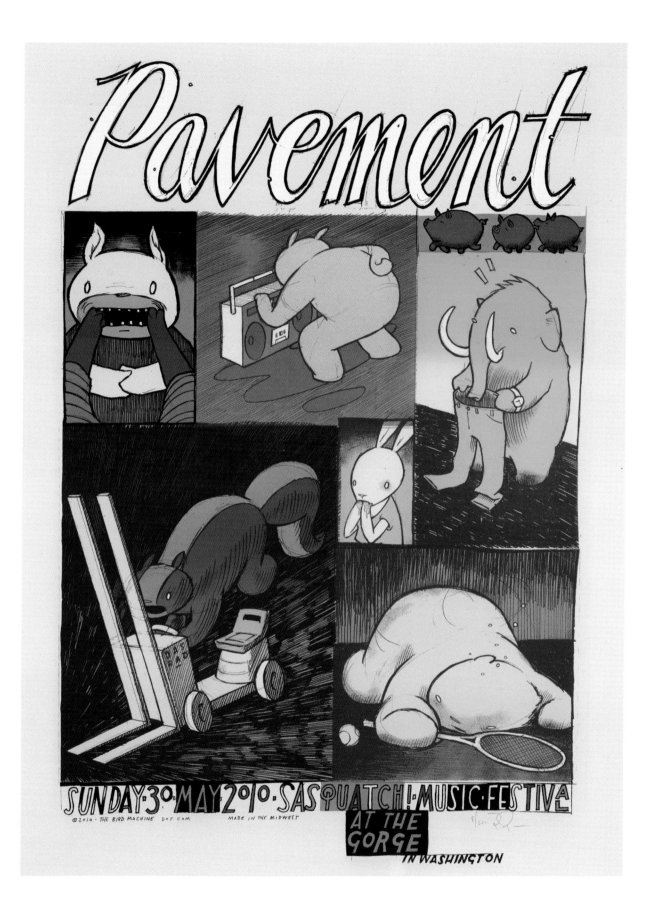

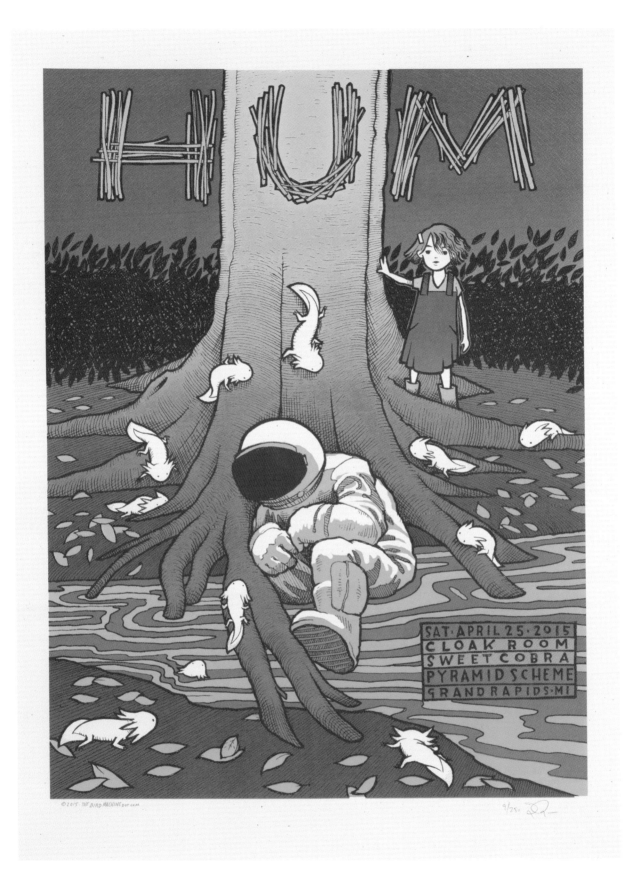

Hum in Grand Rapids
(opposite)

2015
Four screens
18 x 24 inches

Matt Talbott requested a
complex image involving
salamanders, but the idea
transformed into this lost
astronaut being found in a
creek bed in rural Kansas by
a bunch of axolotls and a
particular four-year-old girl.

Poster Children

2009
Four screens
18 x 24 inches

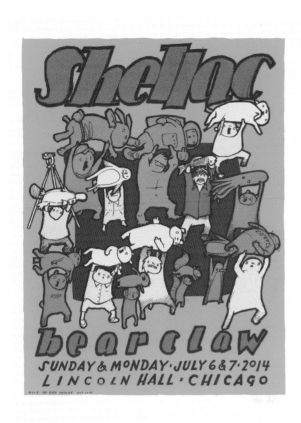

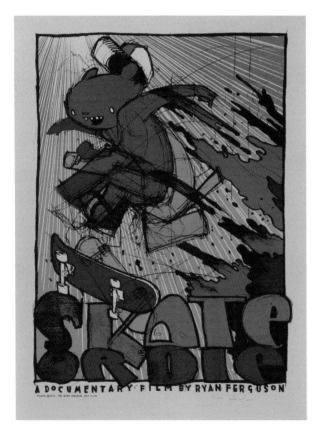

Shellac with Bear Claw (top left)
2014
Five screens
18 x 24 inches

This poster made slightly more sense after the Shellac album *Dude Incredible* was released, two months after this show.

***Skate or Die* (bottom left)**
2012
Five screens
18 x 24 inches

Promotional poster for a documentary about a young man in Chicago who navigates a way out of his neighborhood's violence though skating.

Stephen Malkmus & the Jicks (opposite)
2014
Four screens
18 x 24 inches

I shot process photos while making this print for the former Pavement lead fellow, and used the photos in my traveling university slide lecture for a couple of years.

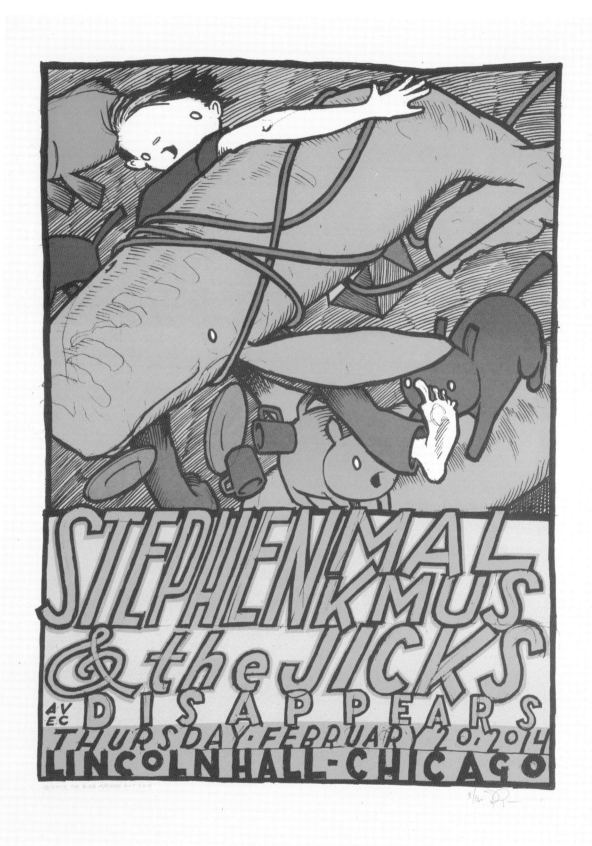

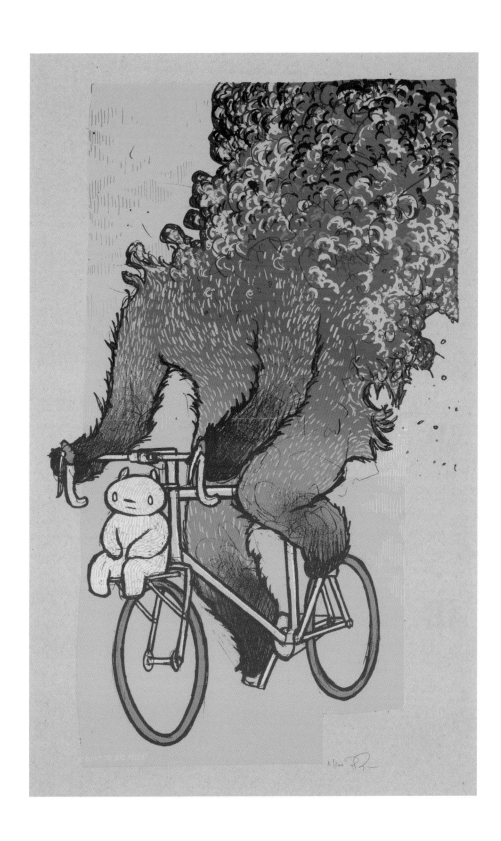

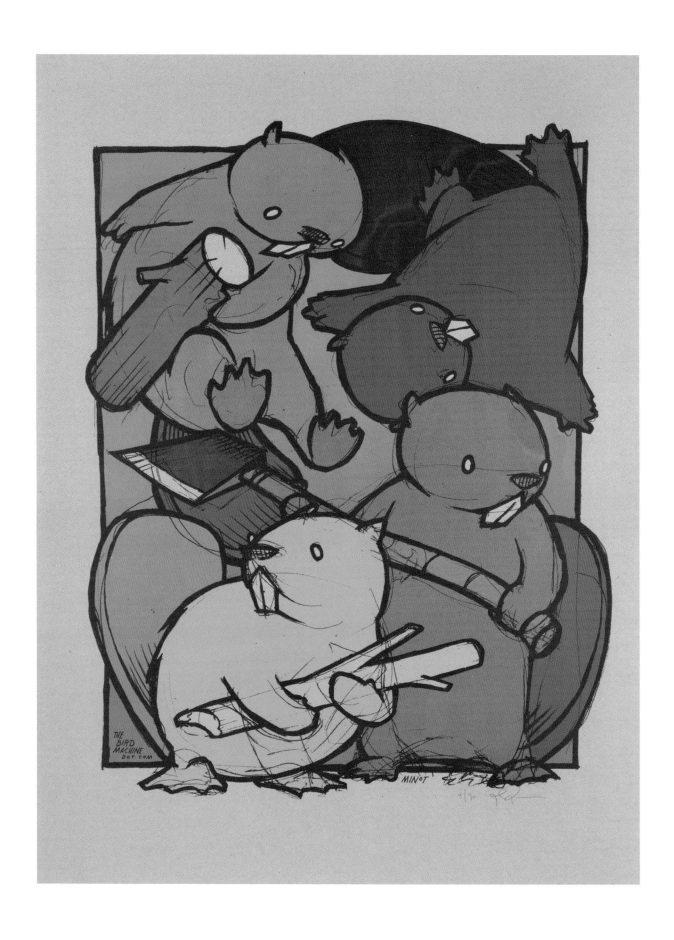

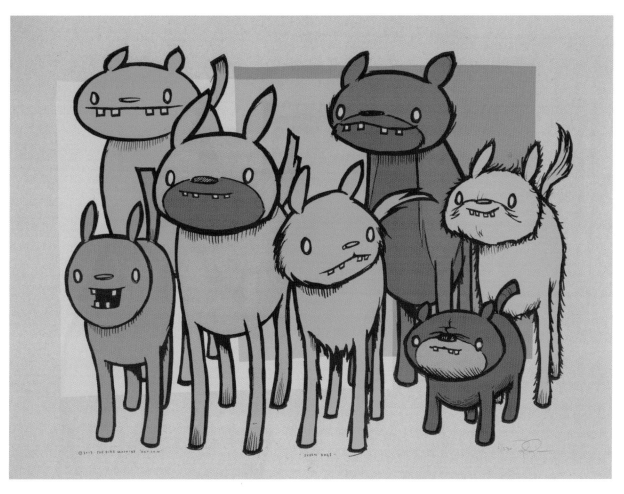

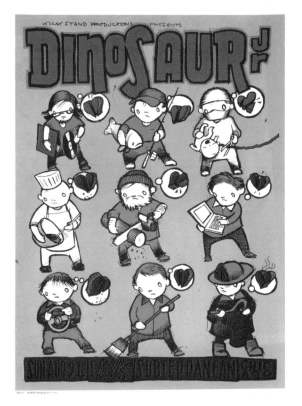

Minot Quartet (opposite)
2012
Six screens
18 x 24 inches

I printed live in the student lounge (called the Beaver Dam) at Minot State University (North Dakota) during a two-day print demonstration. There were a few technical issues, including a nearby exterior door which occasionally kept the snow out, and a group of nursing students who placed glitter-drenched pumpkins waaaaay too close to me.

Seven Dogs (top)
2013
Five screens
18 x 24 inches

**Dinosaur Jr.
(bottom left)**
2015
Three screens
18 x 24 inches

This job caused me to go back and listen critically to *You're Living All Over Me, Bug, Green Mind,* and other old favorites, and what I heard as I distilled the songs down was the idea of not having love, whether it's lost, missed, misplaced, or simply desired. I tried to exemplify this through multiple versions of this one character, which immediately reminded me of why I prefer to draw animals—too many comments and complaints about the specificity of the person in the print.

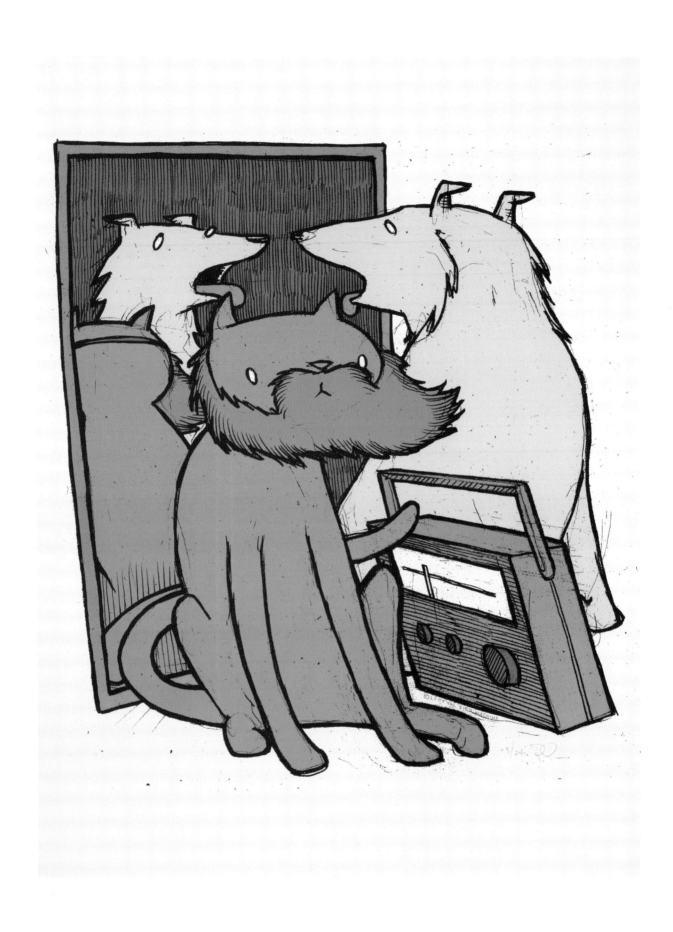

Fake Beard (opposite)
2009
Four screens
17.5 x 23 inches

Some animals know how to
use mirrors.

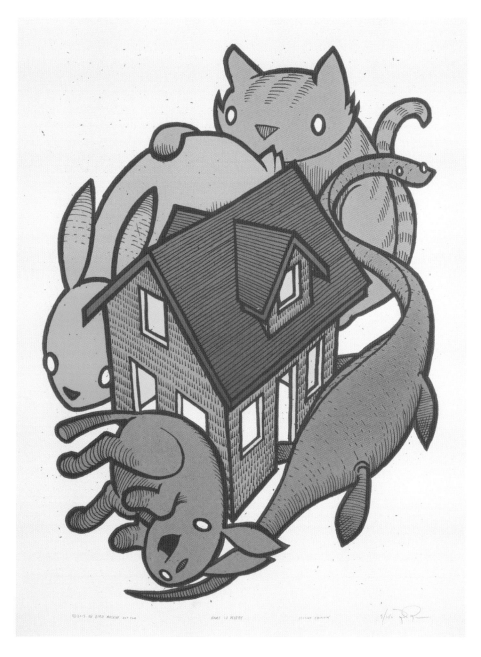

**Home Is Where
(The House Is)**
(second edition)
2015
Four screens
18 x 24 inches

Originally made during a
fun one-day print demo at
Virginia Tech.

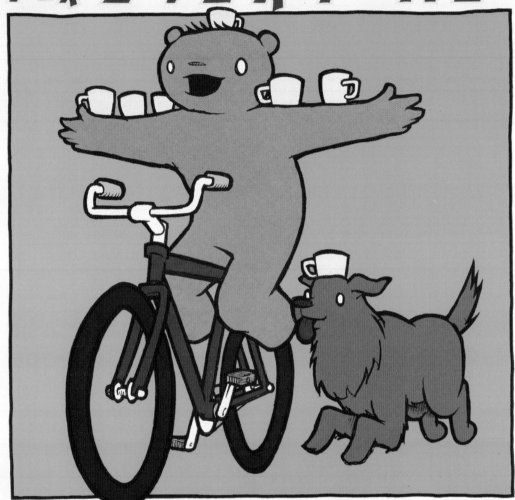

**Great Coffee Is for
Everyone / Metropolis
Coffee Company**
2014
Five screens each
18 x 24 inches

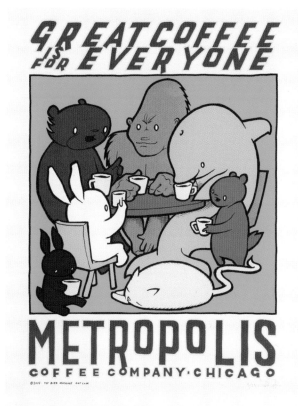

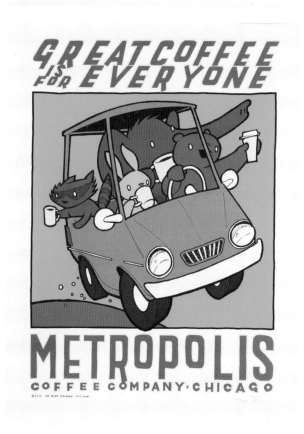

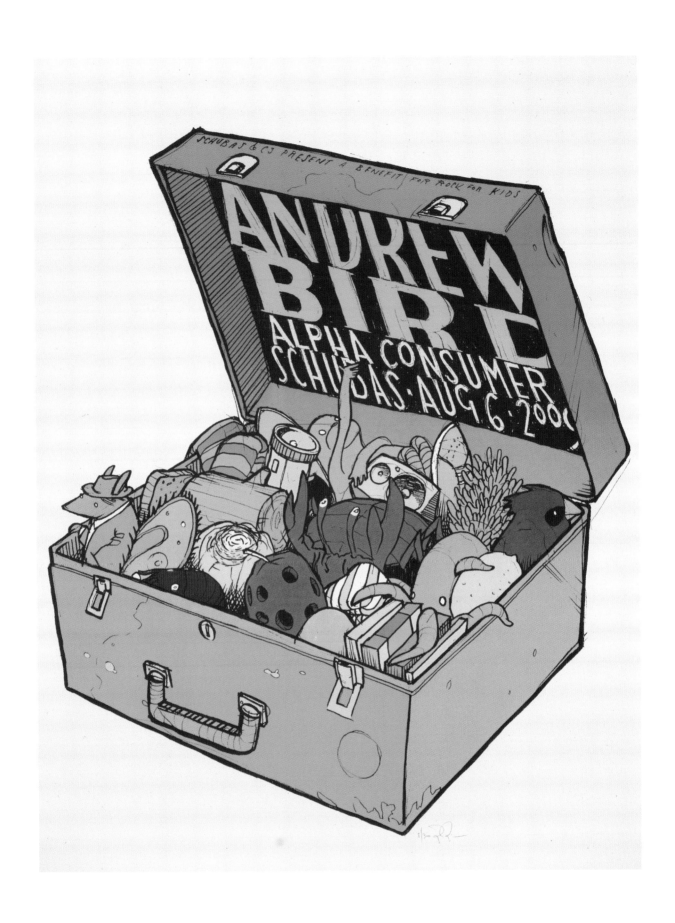

Andrew Bird at Schubas (opposite)
2009
Six screens
20 x 26 inches

Most of the contents of the suitcase were Andrew's actual possessions (such as the blue shoes and the sock monkey) or references to jokes, food, and lyrics.

Andrew Bird at the Hideout (bottom)
2012
Seven screens
18 x 24 inches

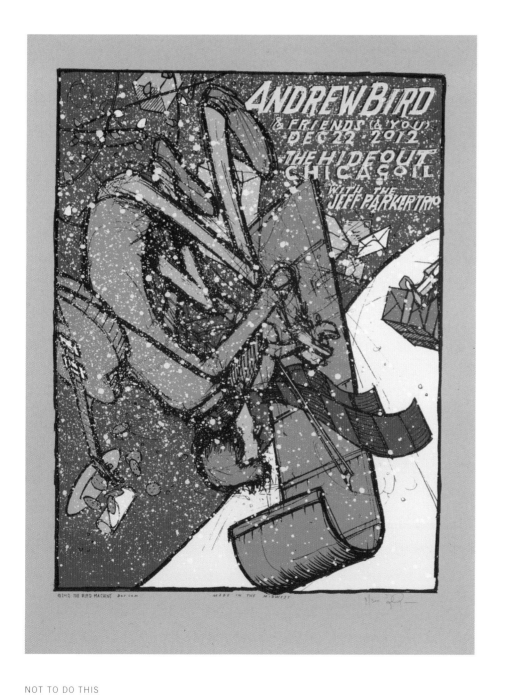

2009
Five screens
20 x 26 inches

"The Giant of Illinois" is a song
by the Handsome Family, which
Andrew has been covering,
and requested as a theme for
the print. Seth the greyhound
appears on the scene.

Andrew Bird in Boulder
2014
Seven screens
18 x 24 inches

The initial thought was to
make three white horses, but
we ended up with mammoths
instead. Five layers of grass
from this print were also used
on the updated packaging for
the *Weather Systems* LP.

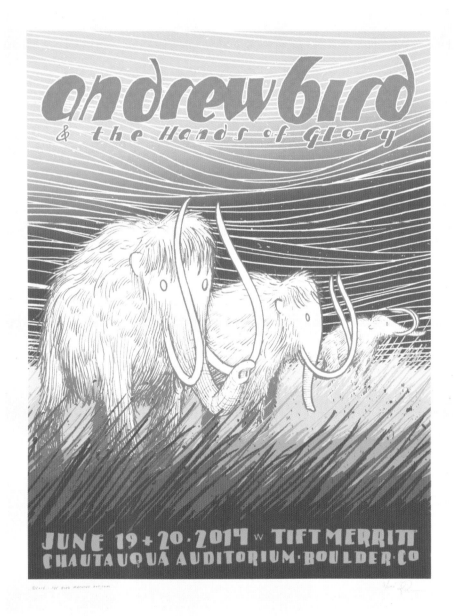

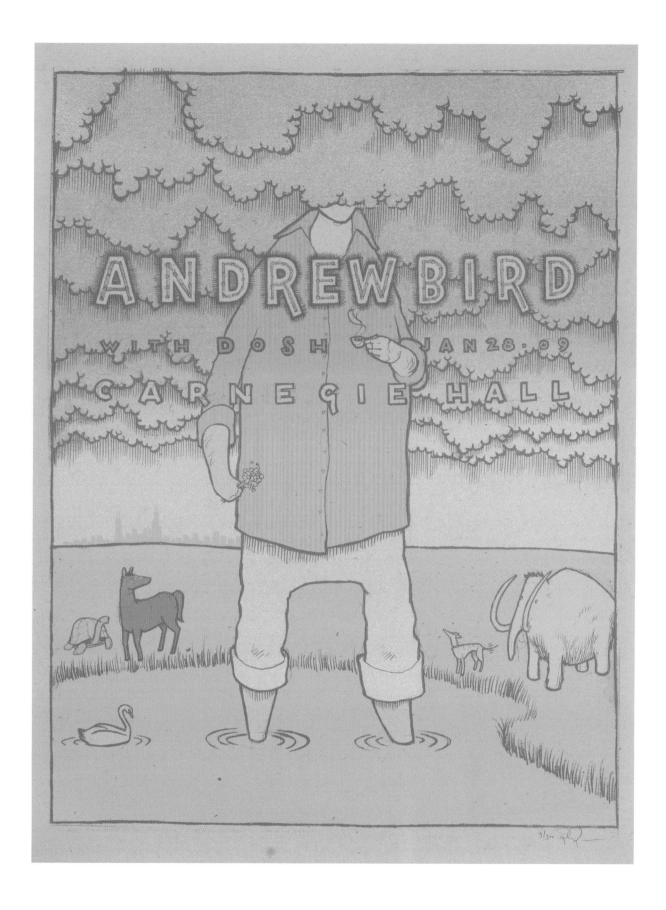

Rendezvous
2015
Six screens
18 x 24 inches

This illustration was rejected as a concert poster for a client, so I removed the text and was very happy with how the image worked by itself.

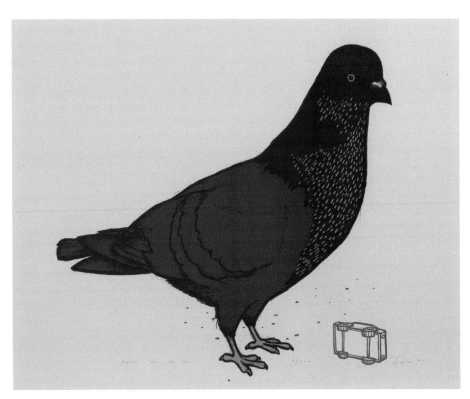

Pigeon Triptych

These four prints were made for a bird-themed show at Depaul University in 2010.

Pigeon with Toy Car (left)
2010
Eight screens
24 x 30 inches

Pigeon with Pencil (bottom)
2010
Eight screens
24 x 30 inches

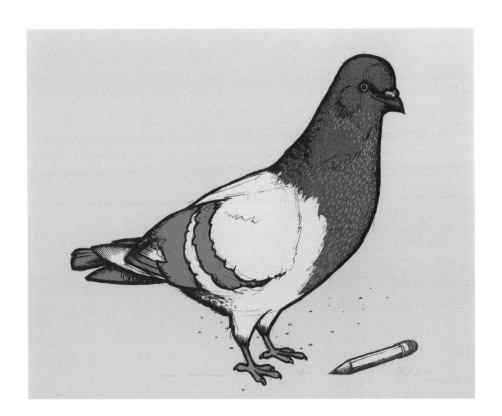

NO ONE TOLD ME

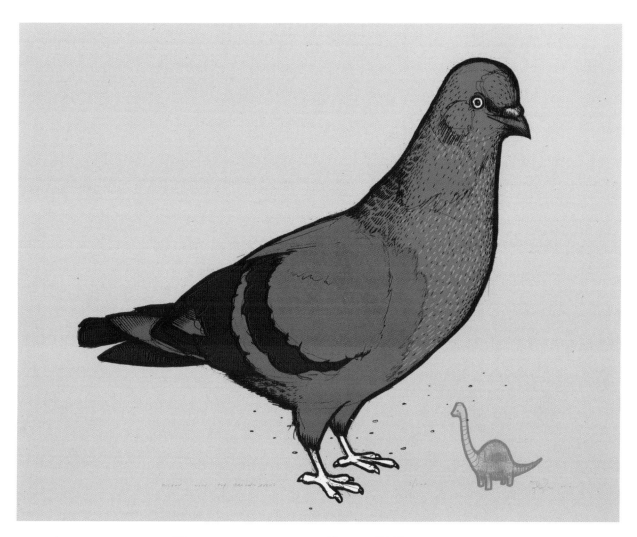

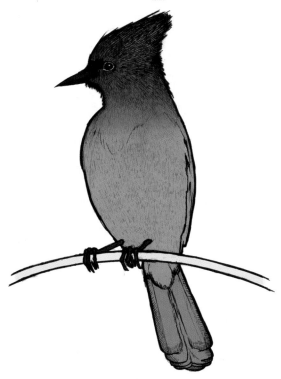

**Pigeon with Toy
Brachiosaurus (above)**
2010
Eight screens
24 x 30 inches

Steller's Jay (left)
2010
Seven screens
24 x 30 inches

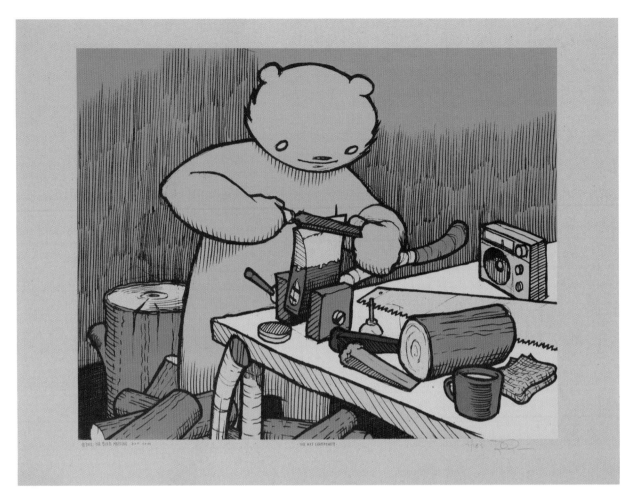

The Axe Sharpener
2012
Six screens
18 x 24 inches

A tribute to those who are
willing to repair old tools
and then use them.

**The Log Hunters
(opposite)**
2011
Five screens
18 x 24 inches

This was made soon after my
daughter was born, as I was
looking forward to activities we
could do together.

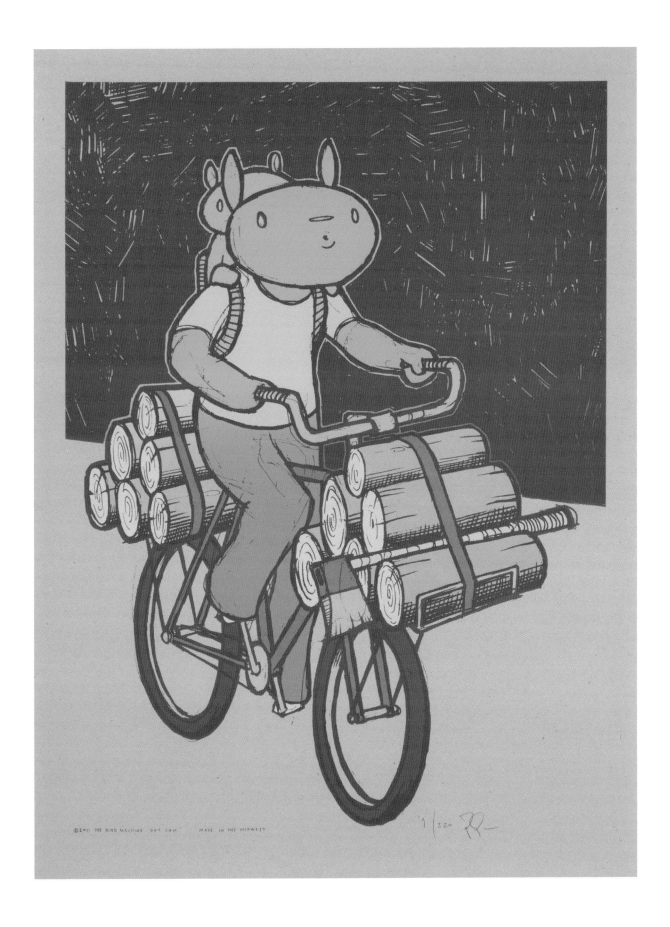

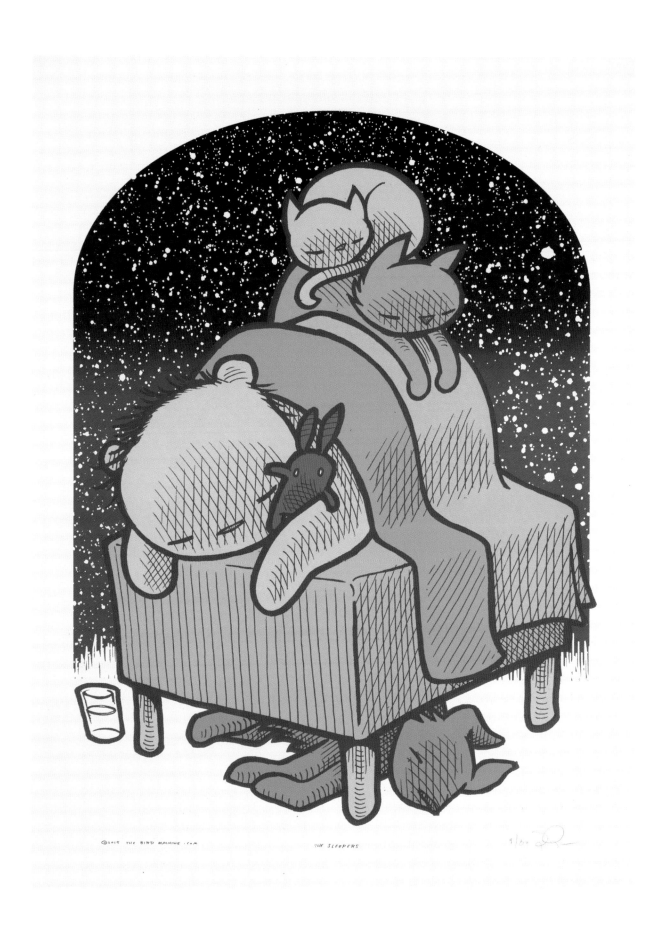

THE SLEEPERS

9/200

The Sleepers (opposite)
2015
Five screens
18 x 24 inches

**Just Like Being
There, Rapid City, SD
(bottom left)**
2015
Three screens
18 x 24 inches

I was invited to speak in South
Dakota on the same day as a
screening of *Just Like Being
There,* a good documentary
about our contemporary poster
scene. Rapid City, just this side
of Devil's Tower, and down the
road from the towns of Dead-
wood and Sturgis, is home to
Dinosaur Park, a scenic hilltop
collection of charmingly inaccu-
rate prehistoric reptile statues.

Clod Play (top right)
2009
Four screens
11 x 17 inches

This print was commissioned
for the special edition of the
book *Rock Paper Show:
Flatstock Volume 1.* I tried to
summarize one or two of the
feelings associated with having
a Flatstock booth.

**Jay Ryan at Virginia Tech
(bottom right)**
2015
Three screens
18 x 24 inches

The art direction I received
for this print was, "Architecture
or sheep."

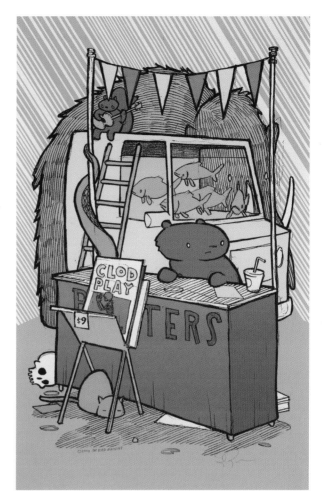

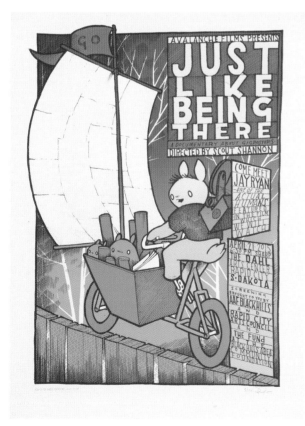

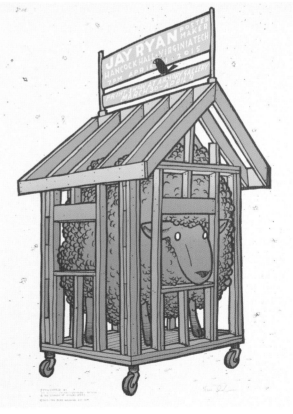

In the Shop (opposite)
2011
Seven screens
18 x 24 inches

Based on the first cover I made
for *Bicycle Times Magazine*.

Flatstock 25
2010
Six screens
18 x 24 inches

For the 25th Flatstock poster
convention, we headed back to
San Francisco, where Flatstock
originated in 2002. This is an
updated version of my poster
for the first event. Oddly, the
printer in this poster bears
a certain similarity to Geoff
Peveto, the longtime
president of the American
Poster Institute, which
organizes these shows.

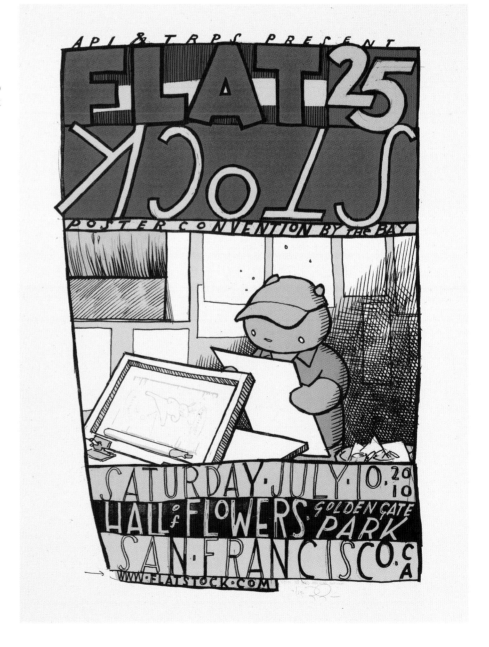

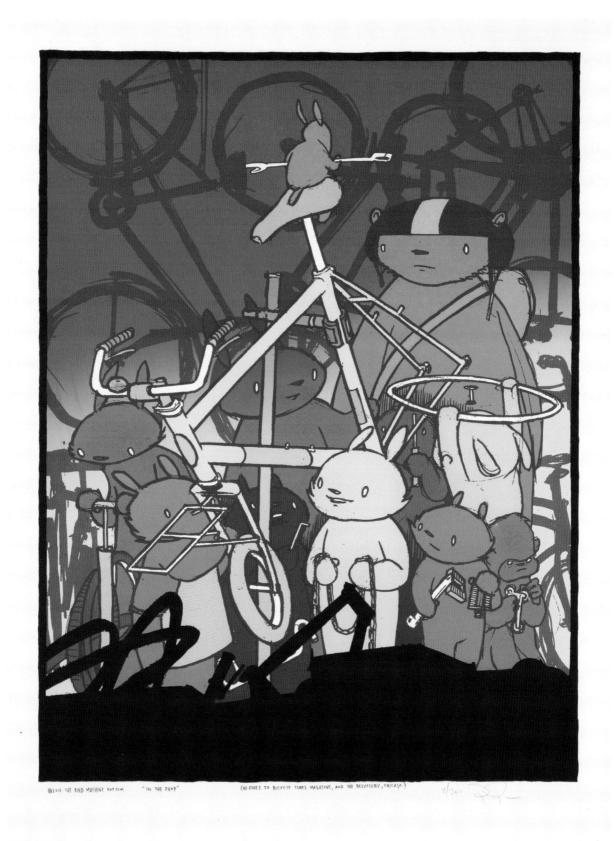

NOT TO DO THIS

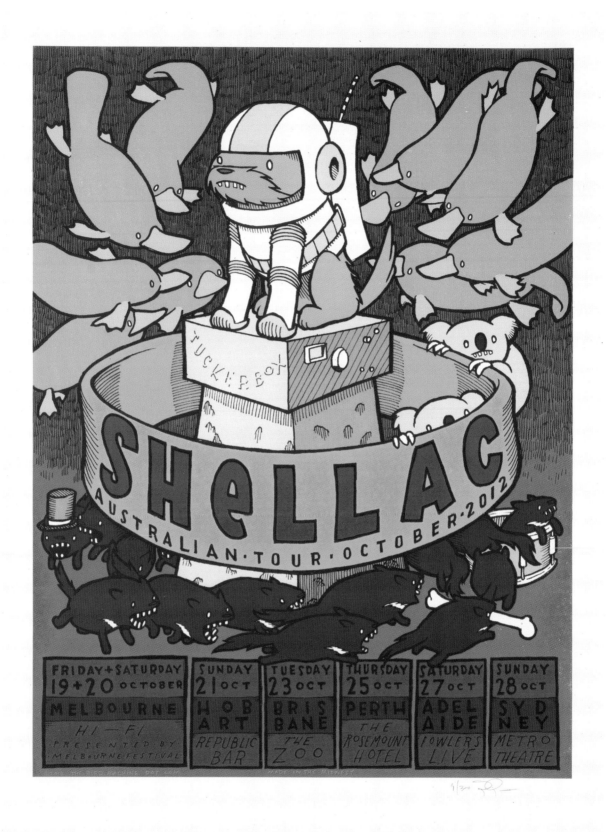

Shellac in Australia (opposite)

2012
Eight screens
18 x 24 inches

The screenprinted version of Shellac's Australian tour poster. Contains a reference to the Dog on the Tuckerbox monument, surrounded by a chorus of ten cherubic platypodes, a couple of drop bears, and some Tasmanian devils (uninfected) ravaging a stray snare.

Total Child (top)

2014
Six screens
18 x 24 inches

Poster for a local preschool.

Oakton Elementary School (bottom)

2010
Five screens
18 x 24 inches

To repay some favors to a friend, I made these prints to support his work fundraising for the PTA of this local school. An administrator suggested that I should not include the school's mascot, the cougar, as that might have scared the children. I did not take this bit of art direction.

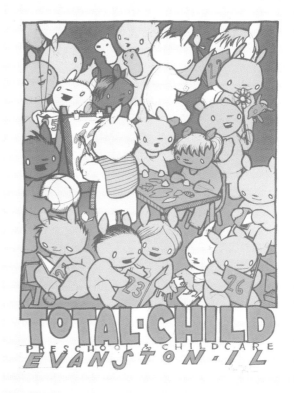

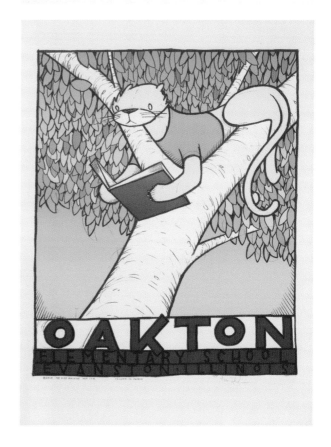

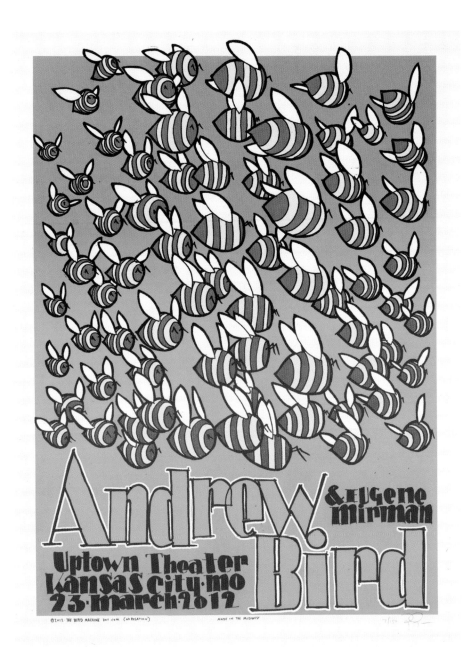

**Andrew Bird in
Kansas City**
2012
Four screens
18 x 24 inches

Based on an element I drew
for a portion of the *Break It
Yourself* album.

**Andrew Bird at
the Beacon Theatre
(opposite)**
2012
Seven screens
18 x 24 inches

Sock Monkey rides again.

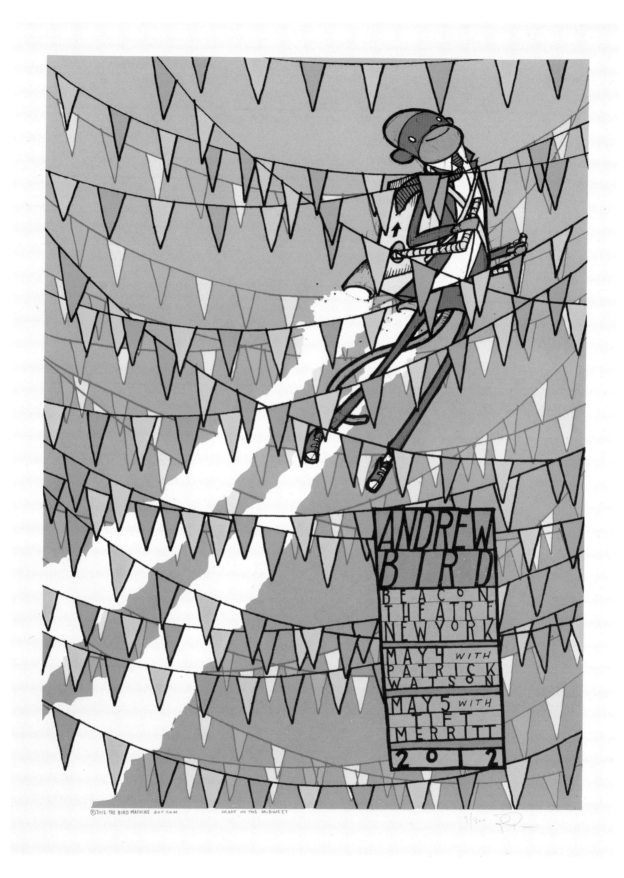

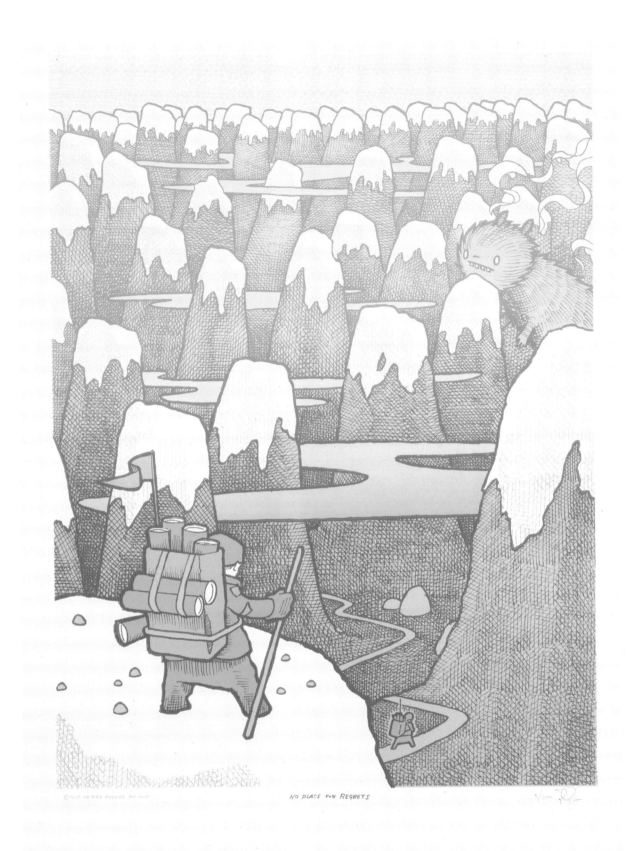

NO PLACE FOR REGRETS

**No Place for Regrets
(opposite) & the National
Poster Retrospecticus**
2014
Three screens each
18 x 24 inches

A print made for this traveling
poster show's stop in Brooklyn,
and a subsequent text-free
version. The National Poster
Retrospecticus was printed by
The Half and Half.

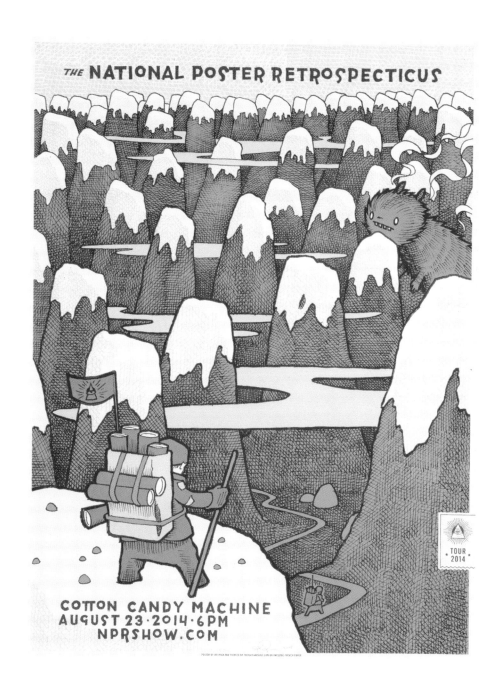

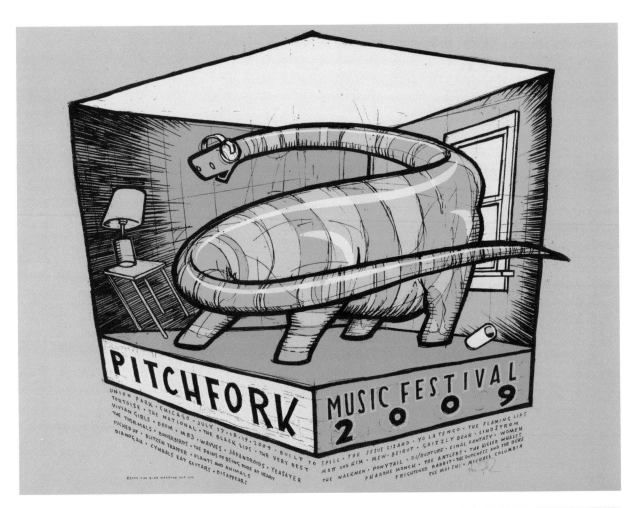

Pitchfork Music Festival (top)
2009
Five screens
20 x 26 inches

Couldn't stop, didn't stop. Shake, shake, shake.

New City / Best of Chicago (bottom)
2014
Eight screens
18 x 24 inches

The annual "Best of Chicago" list from this free weekly paper. The Chicago tradition of "dibs," whereby a resident illegally saves a shoveled parking spot with a chair, is not specifically one of the best things about Chicago, but it's a great way to get some chairs.

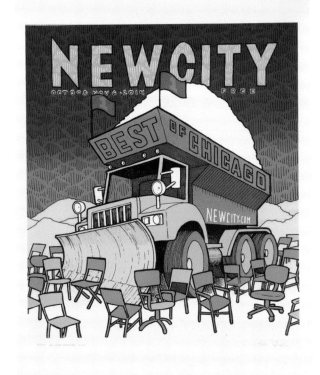

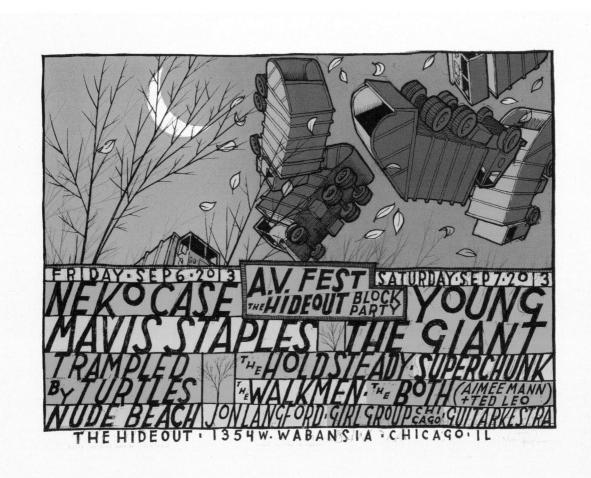

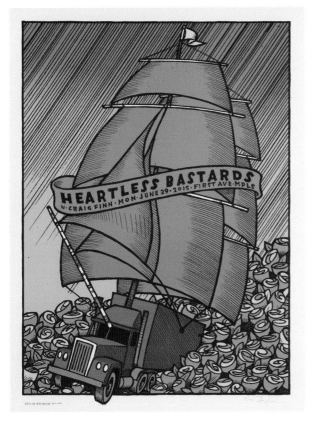

**Heartless Bastards
(bottom)**
2015
Five screens
18 x 24 inches

"The journey is the
destination."

**Hideout Block Party /
A.V. Fest (top)**
2013
Five screens
18 x 24 inches

This event took place in the
big parking lot in front of the
Hideout, where a large portion
of Chicago's garbage trucks
park at night. A thirty-foot-wide
banner of this image, used on-
stage during the concert, now
hangs in the massive truck fleet
repair facility on the far side of
that same parking lot.

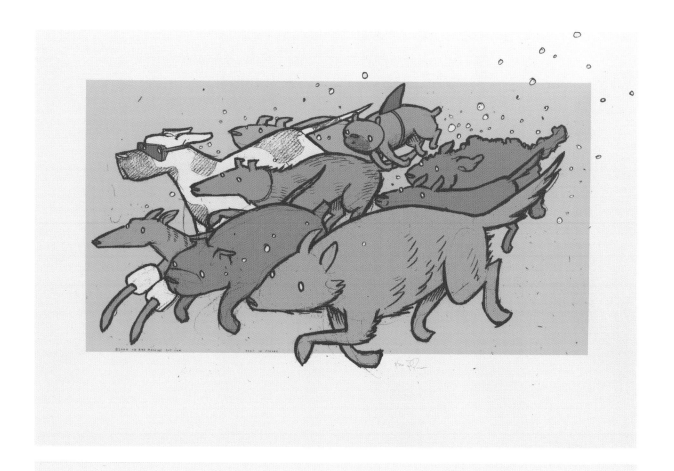

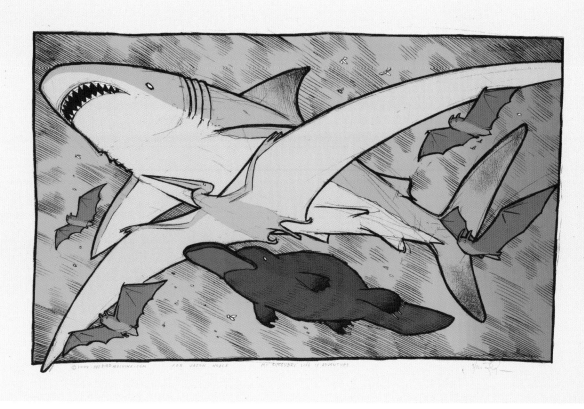

Dogs in School (opposite, top)
2009
Six screens
20 x 30 inches

Patrick Pendergast organized a body of work from different artists and designers around the theme "dogs in school." Seth the greyhound is in the lower left side of the image.

My Everyday Life Is Adventure (opposite, bottom)
2009
Seven screens
12.5 x 19 inches

My contribution to the *Powerful Prints / Powerful Humans* series, benefitting my friend Jason Noble, during his cancer treatment.

Flatstock 20 (bottom)
2009
Four screens
20 x 26 inches

I decided to take a stab at a skulls-and-Hot-Rods-style print for this poster convention.

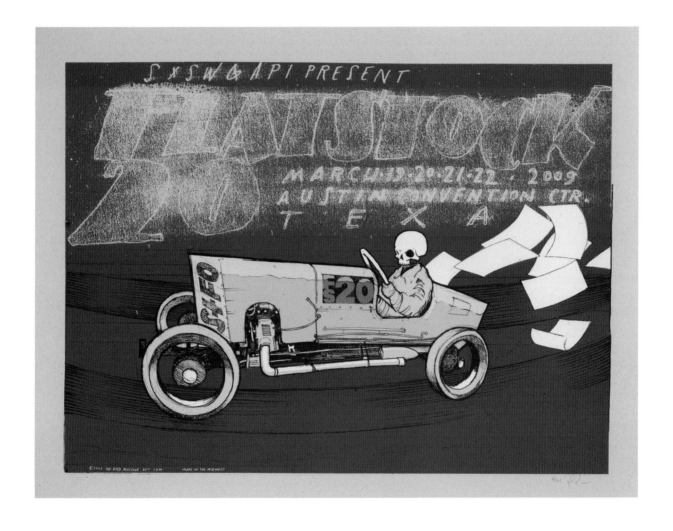

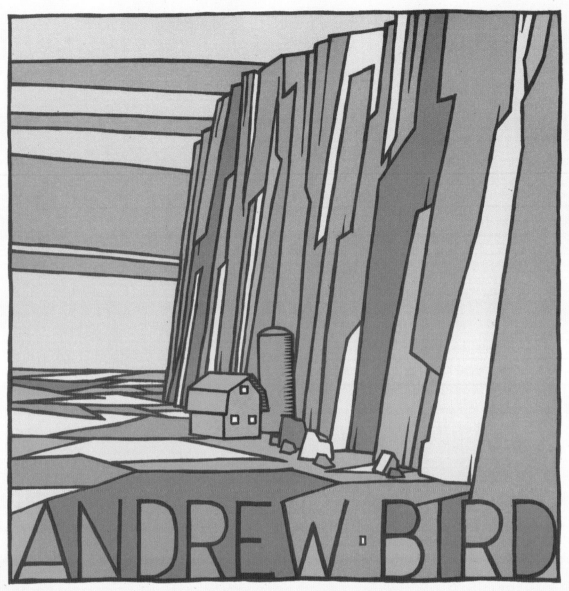

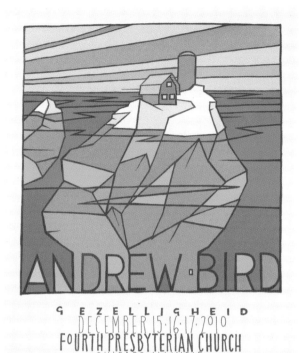

**Andrew Bird Gezelligheid
(opposite and top)**
2010
Seven screens
18 x 24 inches

I tried to make the image look
like stained glass, to fit with the
venues Andrew was playing.
The Barn on top of an iceberg,
and at the base of a glacier.

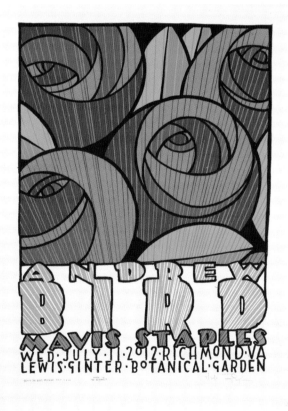

Andrew Bird in Richmond
2012
Four screens
18 x 24 inches

I felt like the little red flowers
from the *Clever Girl* print needed
their own poster.

For Reference (top)
2015
Five screens
18 x 24 inches

Aftermath (bottom)
2014
Five screens
20 x 30 inches

Time to pick up the pieces.

The Incursion (opposite)
2013
Five screens
18 x 24 inches

A bit of rule-breaking
perpetrated by some
charismatic megafauna
and their little buddies.
They're going where they
obviously ought not to go.

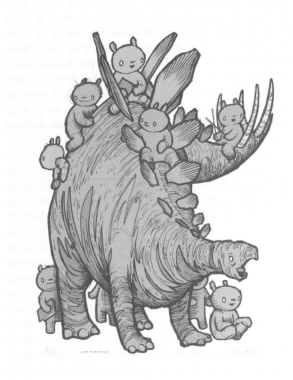

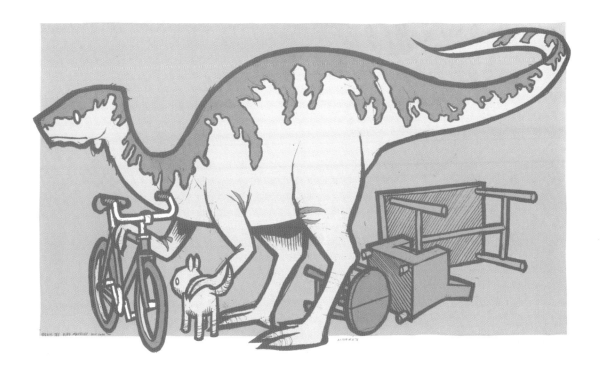

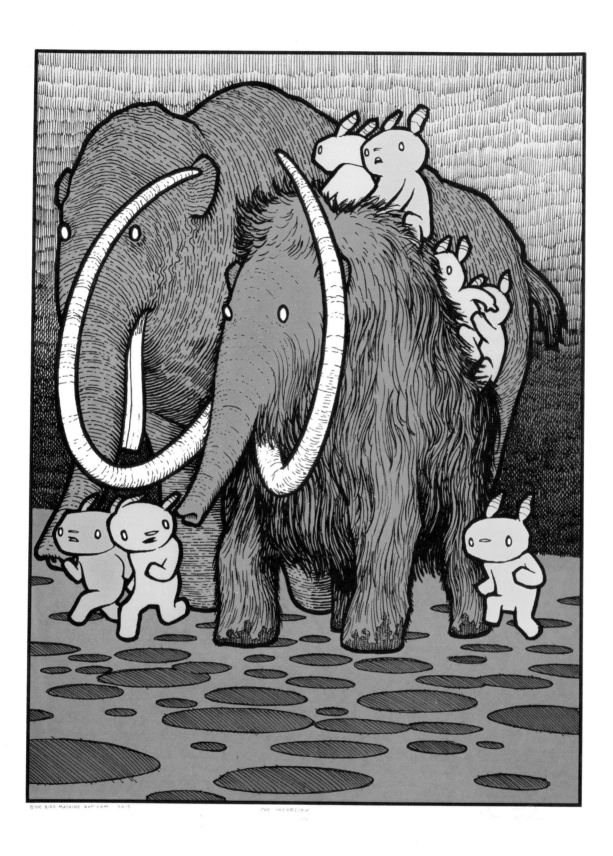

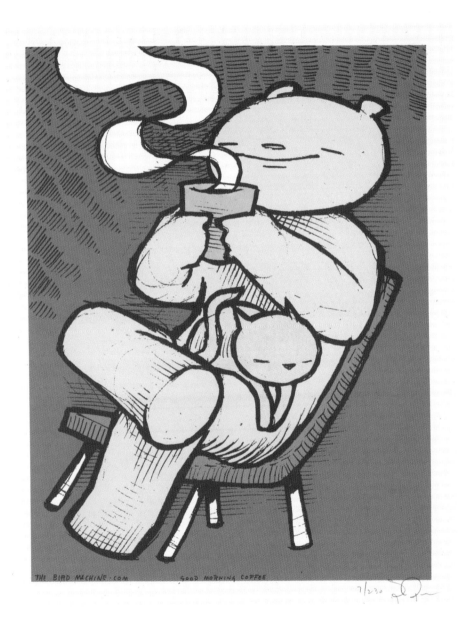

Good Morning Coffee
2014
Four screens
8 x 10 inches

Deliberate lack of punctuation
in the title.

All Set (opposite)
2014
Four screens
8 x 10 inches

A reminder to appreciate what
you have.

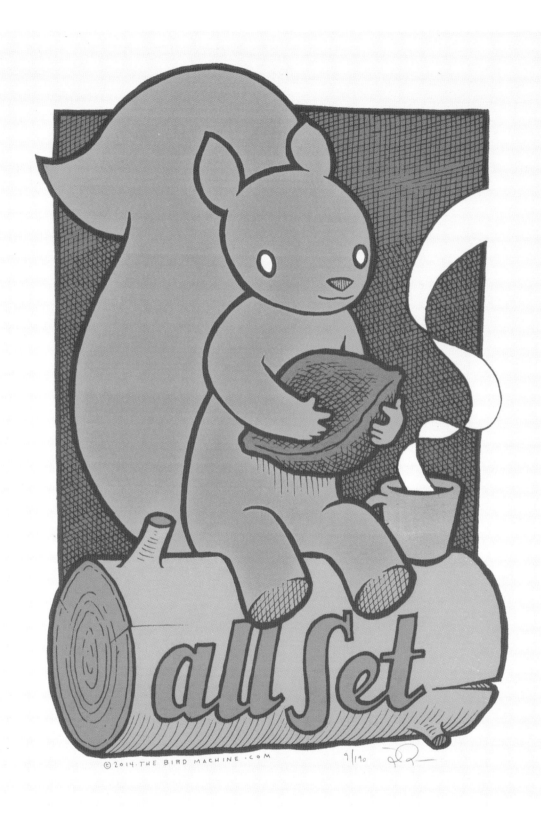

© 2014 · THE · BIRD · MACHINE · .COM 9/190

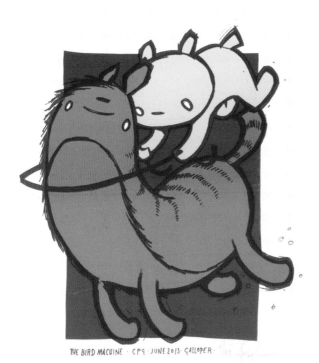

THE BIRD MACHINE · CPS · JUNE 2013 · GALLOPER ·

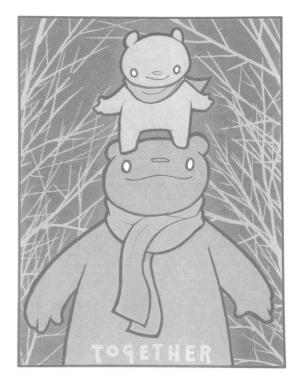

TOGETHER

Galloper (opposite, top left)
2013
Three screens
8 x 10 inches

Small-edition project run as a group activity for a Chicago Printers Guild meeting.

Drop-ship (opposite, bottom left)
2013
Four screens
18 x 24 inches

Together (opposite, top right)
2014
Four screens
8 x 10 inches

A Learning Experience (opposite, bottom right)
2013
Five screens
26 x 40 inches

What sort of trouble has this fellow found himself in now?

Friday, 8 p.m. (right)
2015
Three screens
18 x 24 inches

The end of the work week means different things to different people.

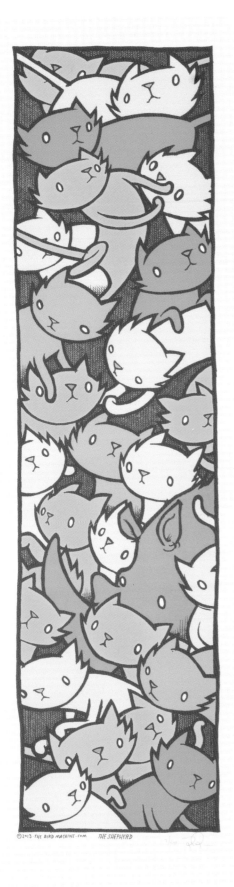

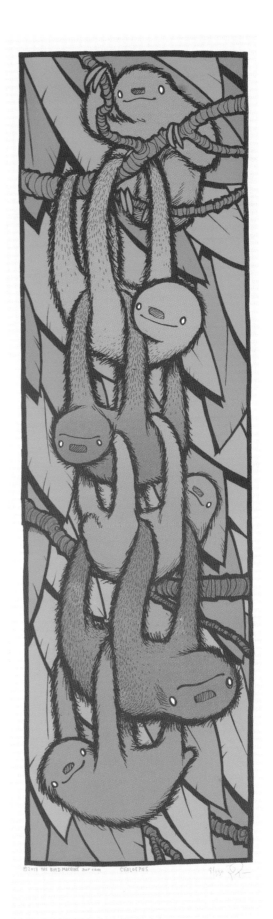

NO ONE TOLD ME

**The Shepherd
(opposite, left)**
2013
Four screens
8 x 28 inches

Someone is trying to herd
these cats.

**Choloepus
(opposite, right)**
2013
Four screens
8 x 28 inches

The best place to keep your
sloth is with your other sloths.

Patience (right)
2013
Three screens
8 x 28 inches

My own take on a page from a
Kevin Henkes children's book
about birds. The writer sees
a tree full of birds and waits
and waits for them to leave,
and they all fly away while he's
turned his head.

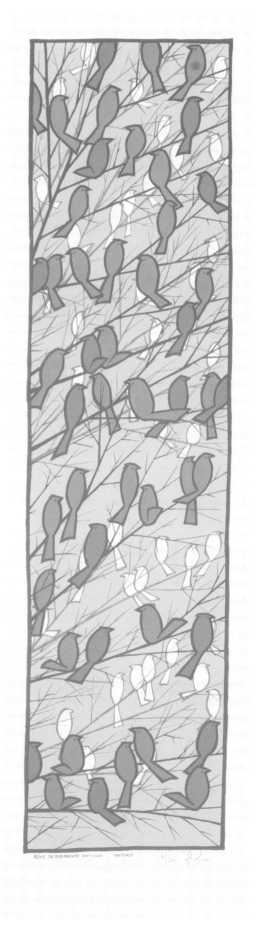

Naughty Dog
2009
Four screens
8 x 8 inches

Tuesday Morning
2013
Three screens
18 x 24 inches

I have not made a conscious decision to draw sleeping mammals so often, but here they are again.

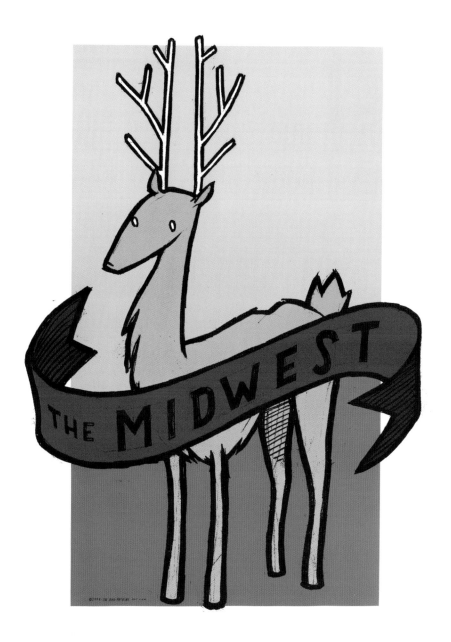

The Midwest
2009
Six screens
25 x 38 inches

Originally made as a tattoo flash
for a friend who still has yet to
get it inked.

NOT TO DO THIS

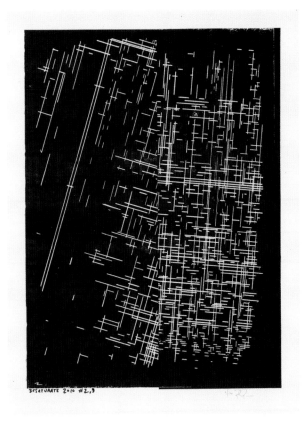

DESATURATE 2010 #2,3

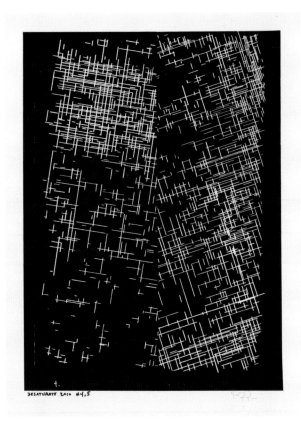

DESATURATE 2010 #4,5

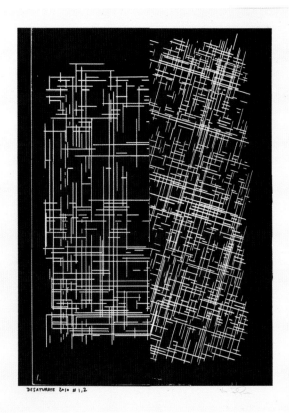

DESATURATE 2010 #1,2

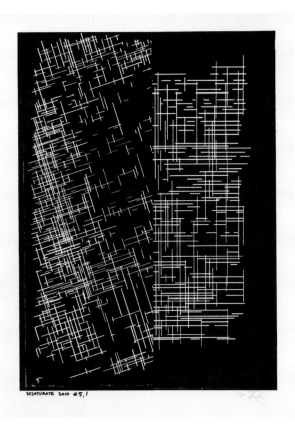

DESATURATE 2010 #5,1

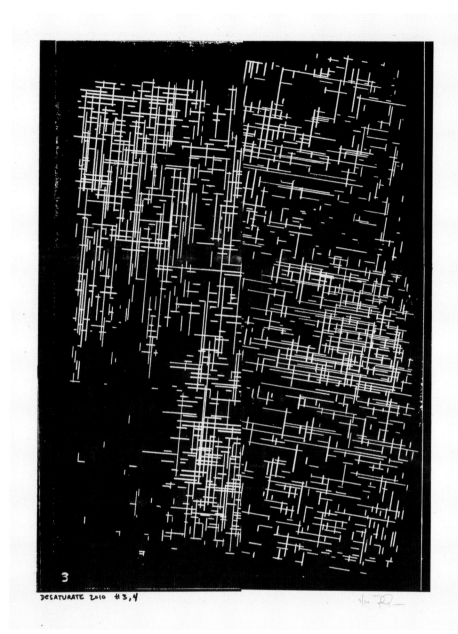

DESATURATE 2010 #3,4

3

Desaturate 2010
2010
Set of five prints
One screen per print
18 x 24 inches

Chicago artist/musician/human Damon Locks organized a show of prints specifically made using one screen, black ink on white paper. These five prints were made from small drawings of perpendicular intersecting lines which were cut and rearranged with mismatched halves.

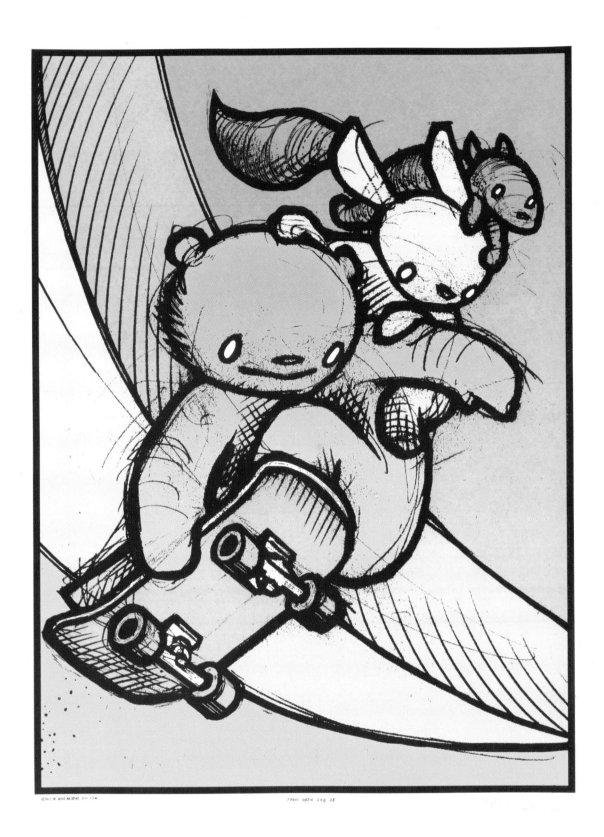

Torn Open for Us
2015
Four screens
18 x 24 inches

Skateboarding pointed me
toward a larger world.

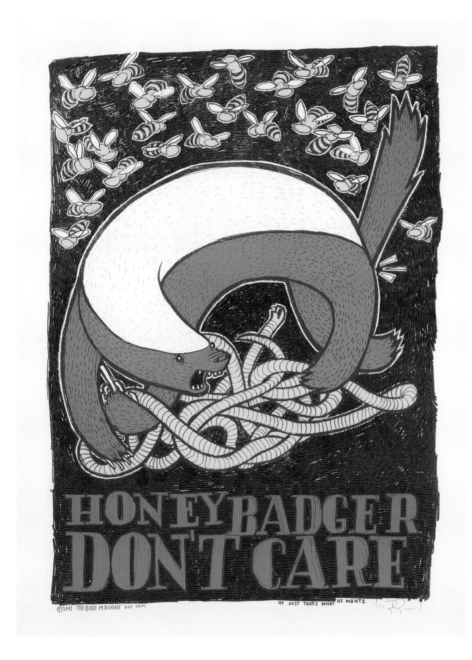

Honey Badger Don't Care
2011
Four screens
18 x 24 inches

My dumb buddy Geoff Peveto
sent me this funny video which
had like 300 hits on YouTube.
I laughed and started making
this print. By the time I was
finished, the *Honey Badger
Don't Care* video had some
number of millions of views.

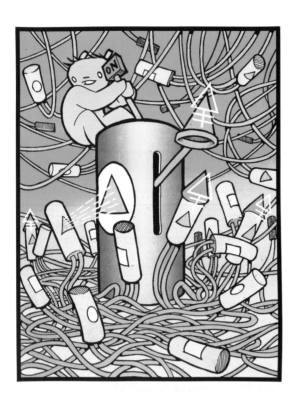

Signaling Machine (top)
2015
Five screens (CMYK plus green)
18 x 24 inches

Illustration commissioned by Eric Weiss at Northwestern University, for *PLOS Biology,* a scientific journal, depicting a metaphor for protein signaling at the cellular level. The small text below the image reads, *An NDR/LATS-Mob complex that controls eukaryotic cell proliferation recognizes specific short docking motifs in otherwise fast-evolving unstructured protein regions.*

Gotcha (I Promise) (opposite)
2012
Seven screens
18 x 24 inches

Print made to help raise legal funds for some friends who were going through a prolonged and complicated adoption process. Their daughter is now legally theirs, thankfully.

The Engine (bottom)
2010
Nine screens
18 x 24 inches

Anders Nilsen invited me to be in a show of artwork about "engines." After years of touring in a van and owning bad mid-size American station wagons, I knew a little something about what is supposed to happen under the hood, and tried to simplify the process down to the basic semirealistic components.

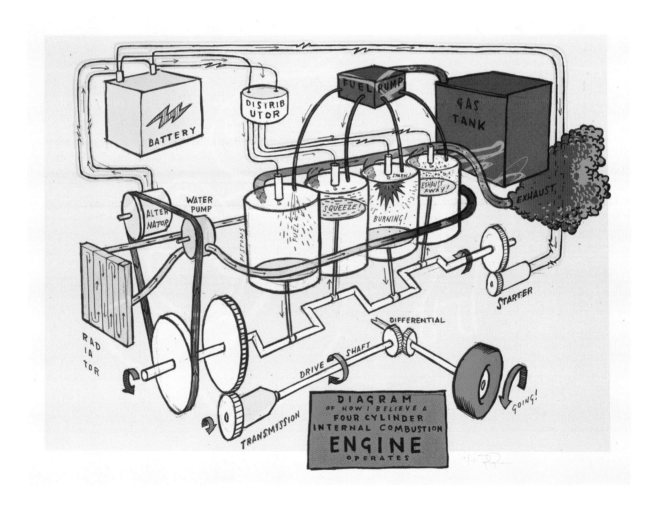

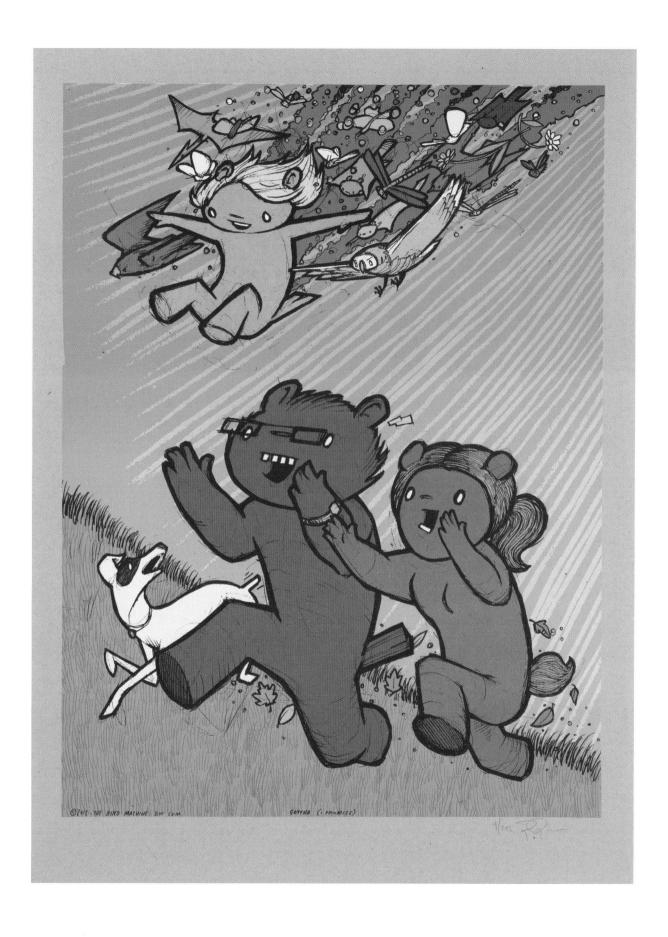

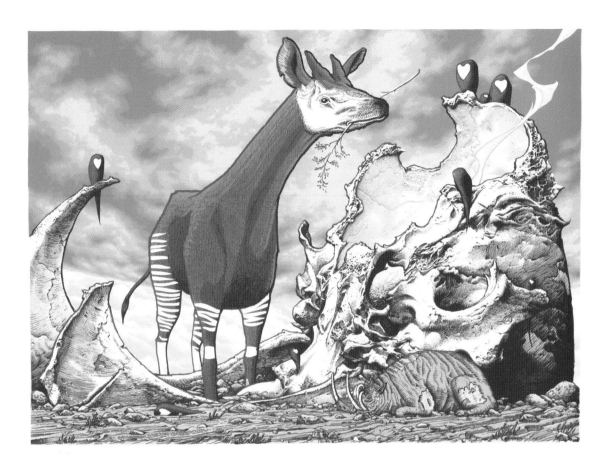

Nunavut
Collaboration with
Aaron Horkey
2011
Eighteen screens
18 x 24 inches

For the third print we made together, Aaron came to the Bird Machine with a drawing of the back of a deer skull he had found in the woods. He extruded some protrusions from the base of the skull and we set a fire inside of it. We found some local animals to tend the fire, including a slumbering babirusa. Aaron took a photo of the sky above a local Dunkin' Donuts and then spent a few days recreating the cloud shapes on film using pointillism and a very small opaquing pen. Those gray clouds aren't photographic—they're hand drawn, one dot at a time, in five layers of progressively darker gray.

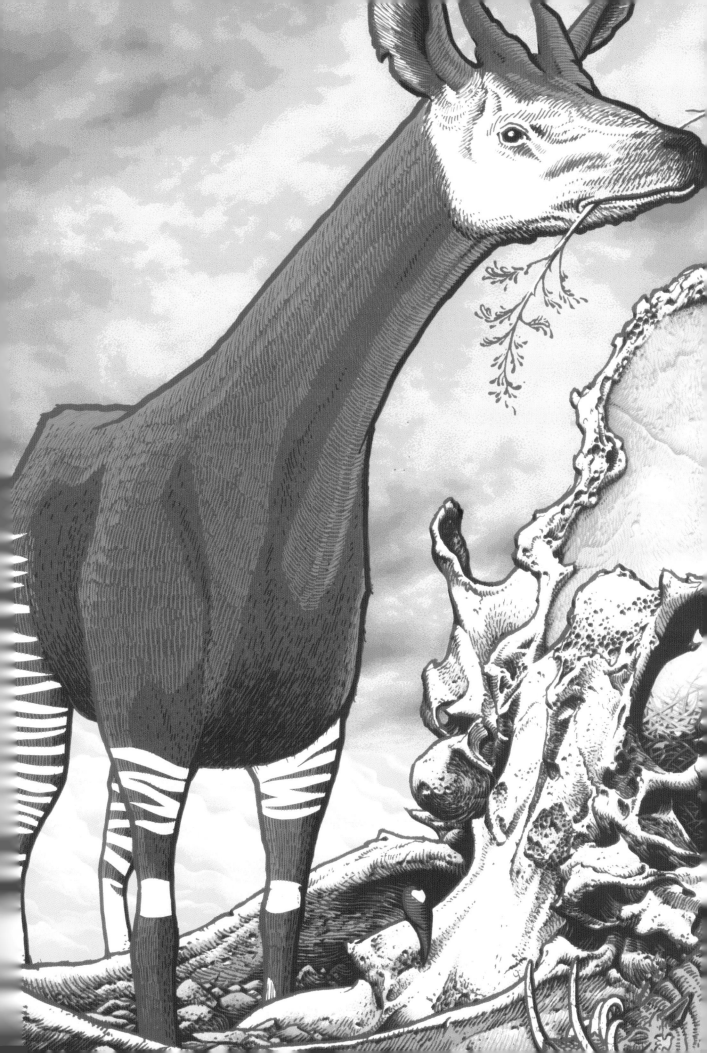

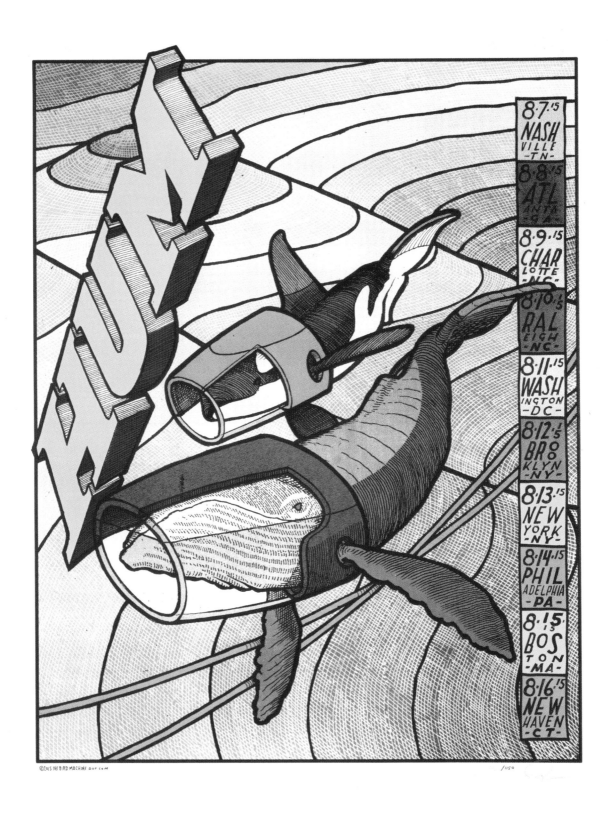

8·7·15
NASH
VILLE
-TN-

8·8·15
ATL
ANTA
-GA-

8·9·15
CHAR
LOTTE
-NC-

8·10·15
RAL
EIGH
-NC-

8·11·15
WASH
INGTON
-DC-

8·12·15
BRO
KLYN
-NY-

8·13·15
NEW
YORK
-NY-

8·14·15
PHIL
ADELPHIA
-PA-

8·15·15
BOS
TON
-MA-

8·16·15
NEW
HAVEN
-CT-

©THIS THE BIRD MACHINE dot com

/1150

**Hum East Coast /
West Coast Tour**
2015
Four screens (CMYK)
18 x 24 inches

Matt Talbott from Hum suggested
two matching nautical maps
for the East and West coasts.
As the drawing developed, it
became more of a topographic
map of the ocean depth. The
topographical lines in the
background on these two prints
flow from one print to the other,
regardless of which print is on
the right or left.

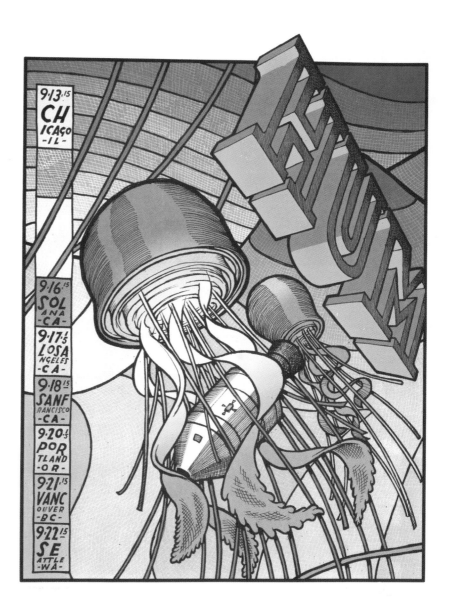

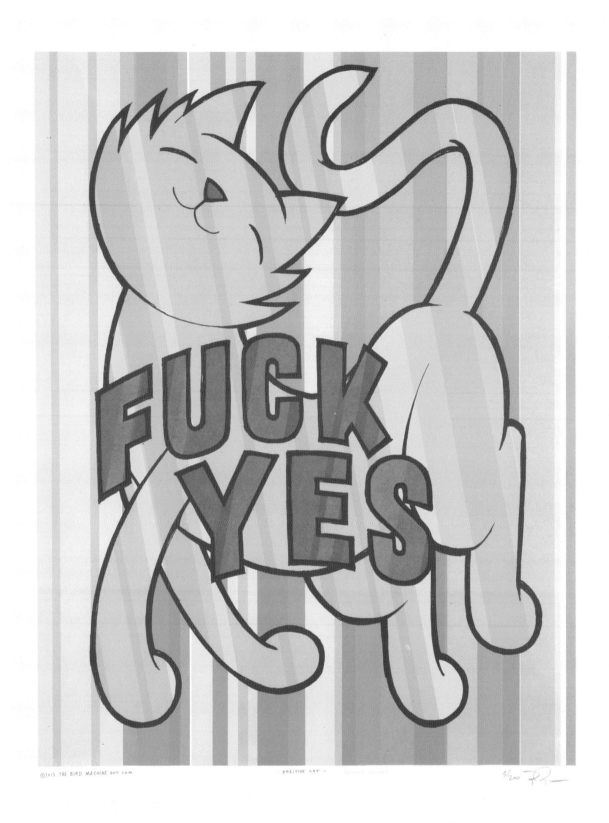

©2015 THE BIRD MACHINE DOT COM — PRSITIVE CAT — 5/200

Positive Cat (opposite)
2015
Six screens
18 x 24 inches

We made two separate editions, with different colors. Apologies to the younger and more sensitive readers for the vulgar word choice, but sometimes we just get excited.

Group Ride
2014
Four screens
18 x 24 inches

A text-free version of our 2014 *Screens and Spokes* print, made to raise funds for multiple sclerosis research.

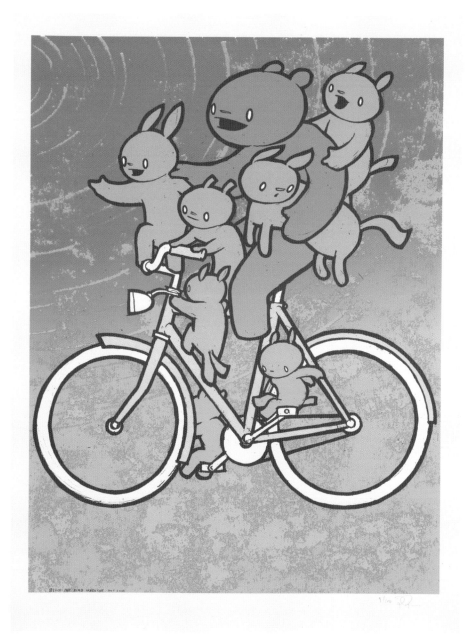

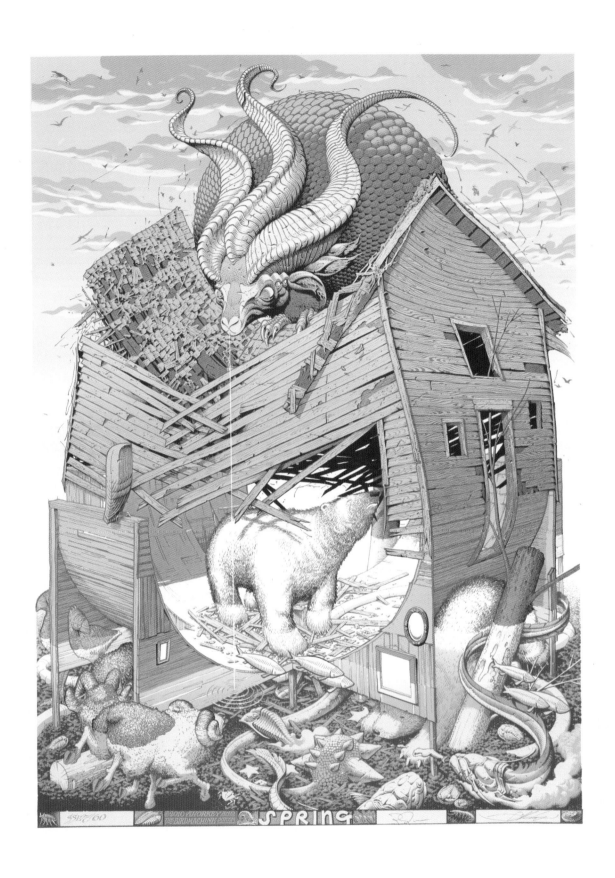

SPRING

NO ONE TOLD ME

Spring (opposite)
Collaboration with
Aaron Horkey
2010
Thirteen screens
19 x 25.25 inches

Heading into the second
collaboration with Aaron
Horkey, I sent him a loose
sketch of intersecting half-pipes
with some sort of monster
wedged underneath. When the
drawing came back to me, the
skateboard ramps had been
lowered and a barn had been
built (and collapsed) on top of
them. Aaron arrived in town
and we worked together on
the drawing. Aaron became
intrigued by a small plastic
owl which my wife keeps on
a bookshelf, and he included
that figure on the near side of
the ramp, above the swimming
six-legged sheep, dunkleosteus,
and trilobites. From a printing
perspective, this project was
interesting in that the subject
of the title, the stream of water
coming from the mouth of the
glyptodont-goat hybrid, is not
printed in white—it's a knock-
out to the color of the paper.
We managed to print cleanly
enough to maintain a nice tight
line, which is not easy. During
the time we worked on this
print, our beloved greyhound
Seth became ill and passed
away, so during the last steps
of printing, we added his hand-
some figure streaking across
the sky in the upper left corner.

Slow Loft (right)
2015
Three screens
18 x 24 inches

A pretty effective use of
three screens.

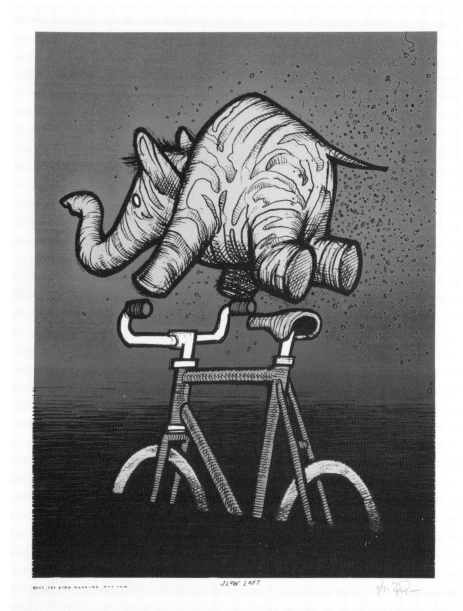

SLOW LOFT

ONWARD, ILLINOIS!

**Onward, Illinois!
(opposite)**
2013
Five screens
18 x 24 inches

The best place to live, with so
much room for improvement.

**Front End Loader
(bottom)**
2014
Seven screens
18 x 24 inches

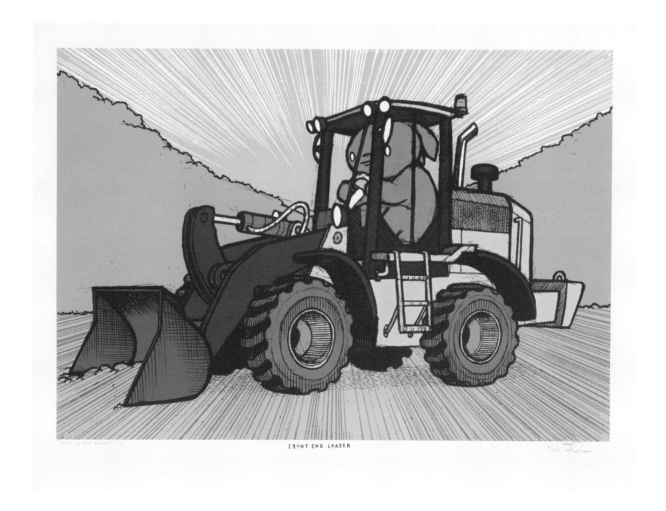

FRONT END LOADER

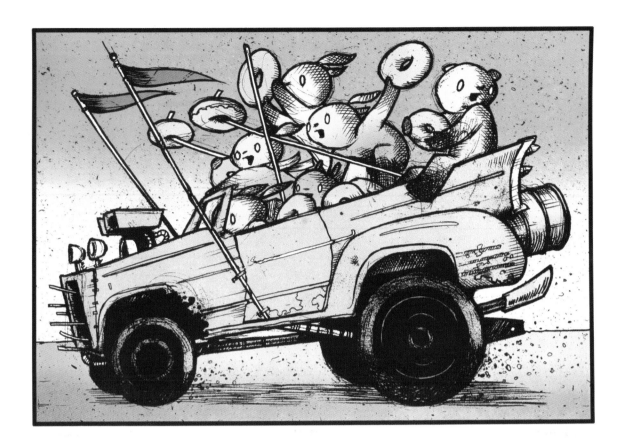

Witness! Donuts!
2015
Five screens
18 x 24 inches

These prints started as I was considering my large morning mocha, and how much pleasure it was bringing to me while on my drive to work. In trying to depict that pleasure (and the way I drive), I touched on what is probably my favorite movie of 2015, which has ridiculous muscle cars tearing across a dusty landscape. Looking further afield, I thought that donuts and tacos often give me the same sense of adventure, but we had just made some taco prints (*No More Disagreements Today*), so my next favorite thing is pizza, which is also pretty adventurous. Vehicles and mammals were drafted, and three of the major food groups were celebrated. All three were printed in CMYK on top of a layer of metallic silver.

Witness! Coffee! (opposite, top)
2015
Five screens
18 x 24 inches

Witness! Pizza! (opposite, bottom)
2015
Five screens
18 x 24 inches

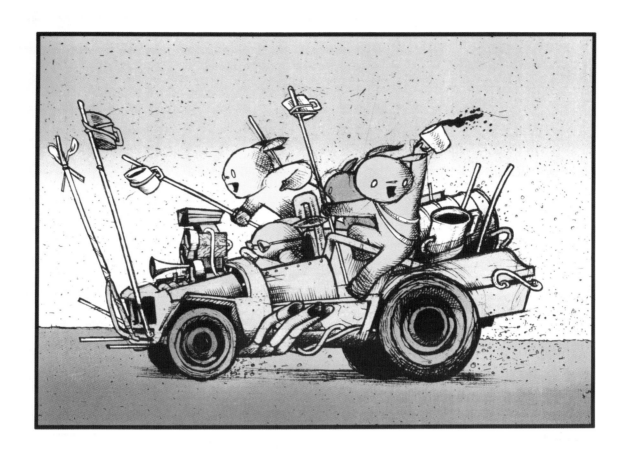

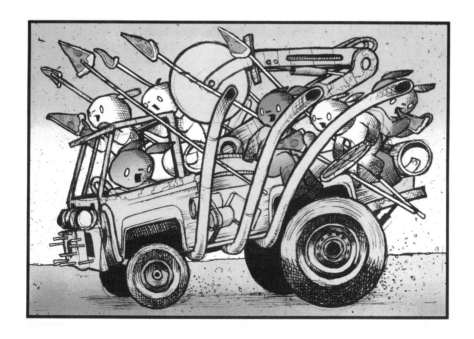

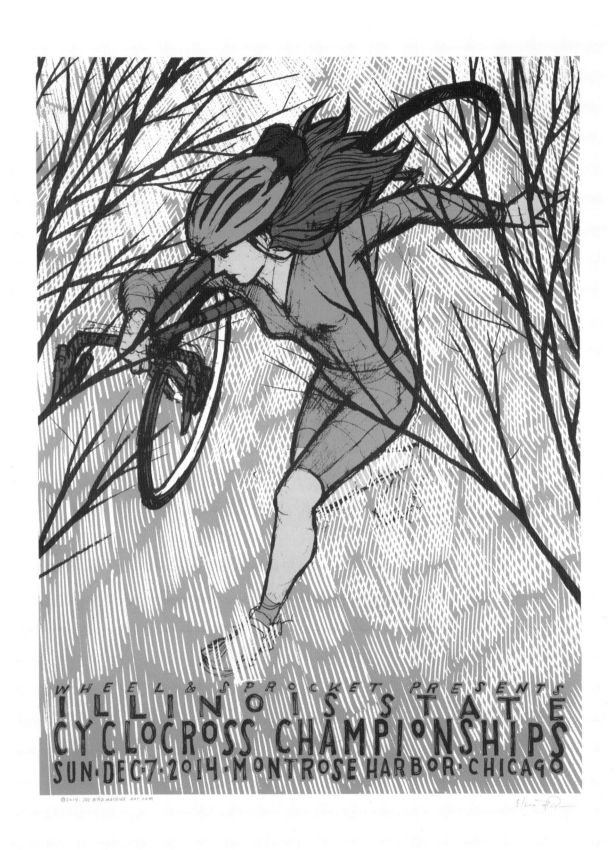

**Illinois State Cyclocross
Championships (opposite)**
2014
Four screens
18 x 24 inches

**Illinois State Cyclocross
Championships (top)**
2011
Five screens
18 x 24 inches

**Ed Rudolph Velodrome
(bottom)**
2010
Six screens
18 x 24 inches

The various annual bike race
posters I get to make challenge
my drawing ability, as I feel they
need to include realistic propor-
tions between the bicycles and
the riders.

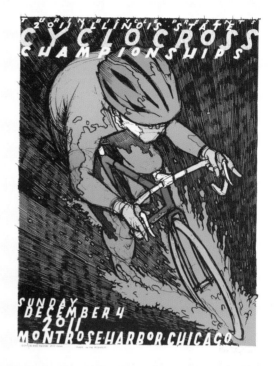

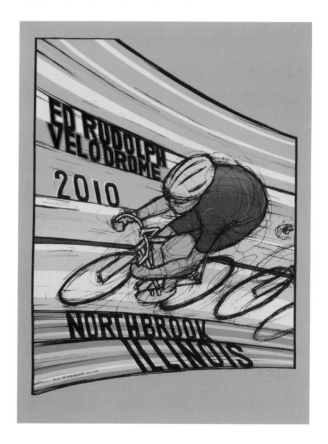

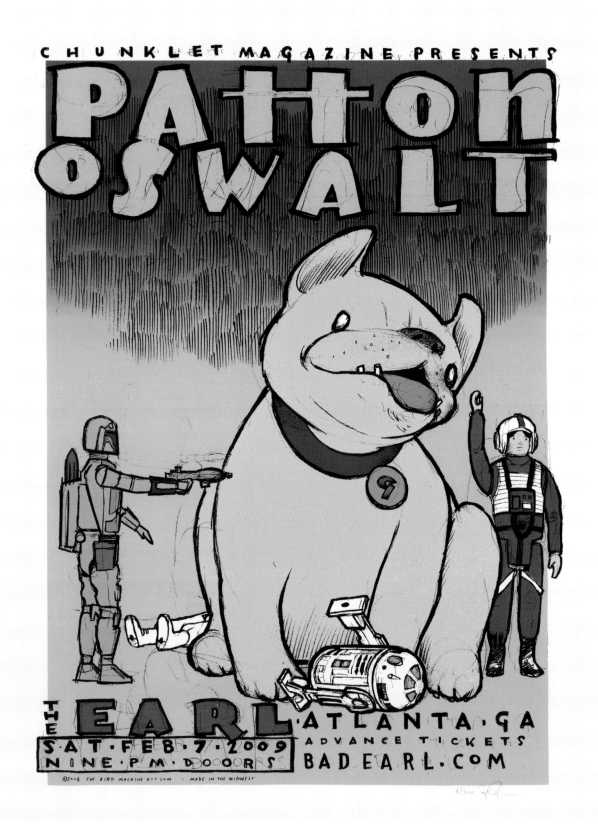

Patton Oswalt
2009
Five screens each
17.625 x 23 inches

Patton's sci-fi nerdiness
is well-documented, as is
his love for his handsome,
now-deceased French
bulldog Grumpus.

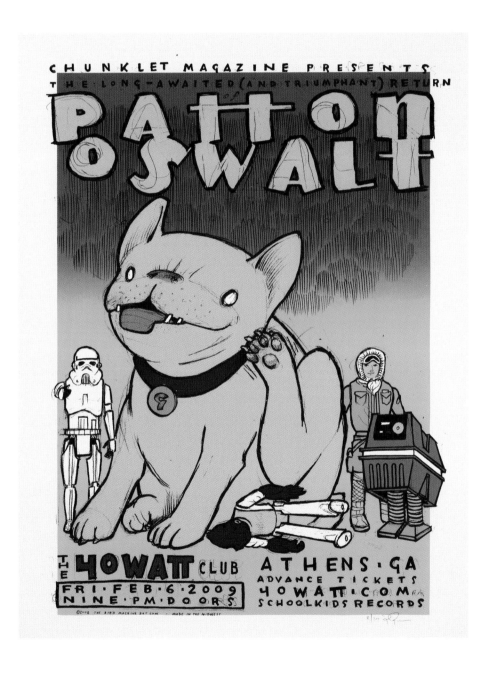

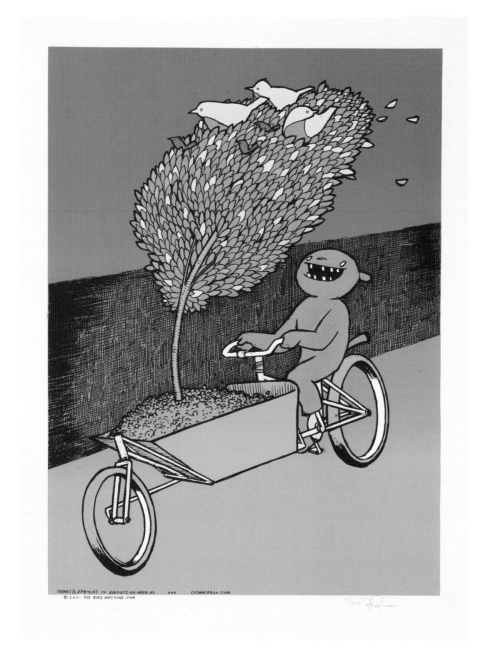

Portable
2011
Six screens
18 x 24 inches

Celebrating the functionality of working bikes.

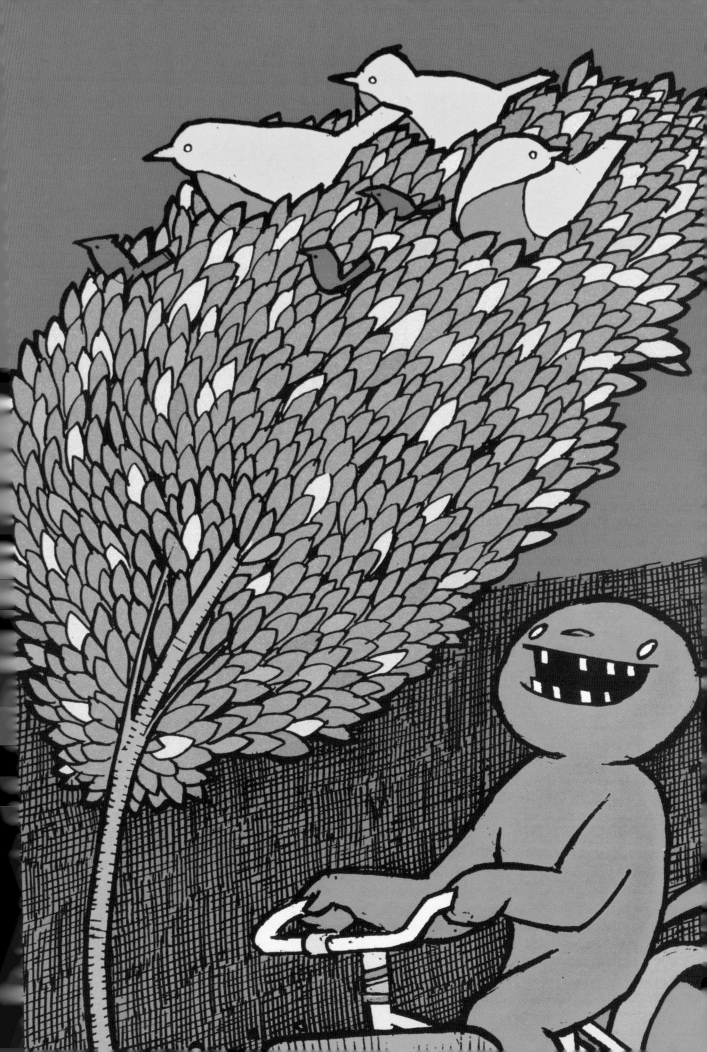

The National (opposite)

The National (opposite)
2010
Four screens
18 x 24 inches

My depiction of the protagonist
of most of the songs on the
album *Boxer*.

**Black Heart Procession,
with Bellini and the
Poison Arrows**
2009
Four screens
18 x 24 inches

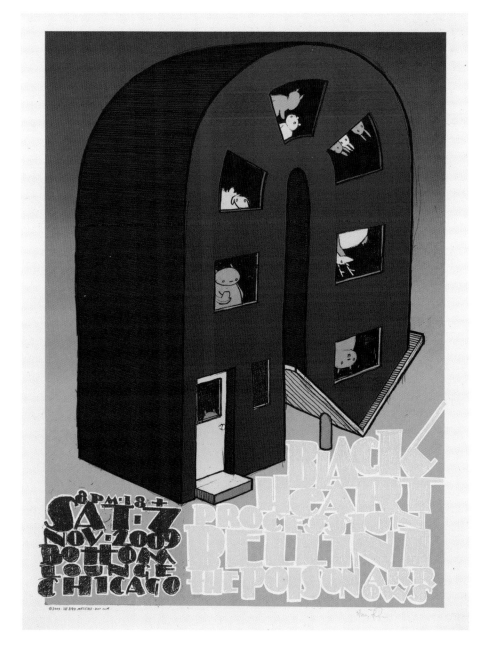

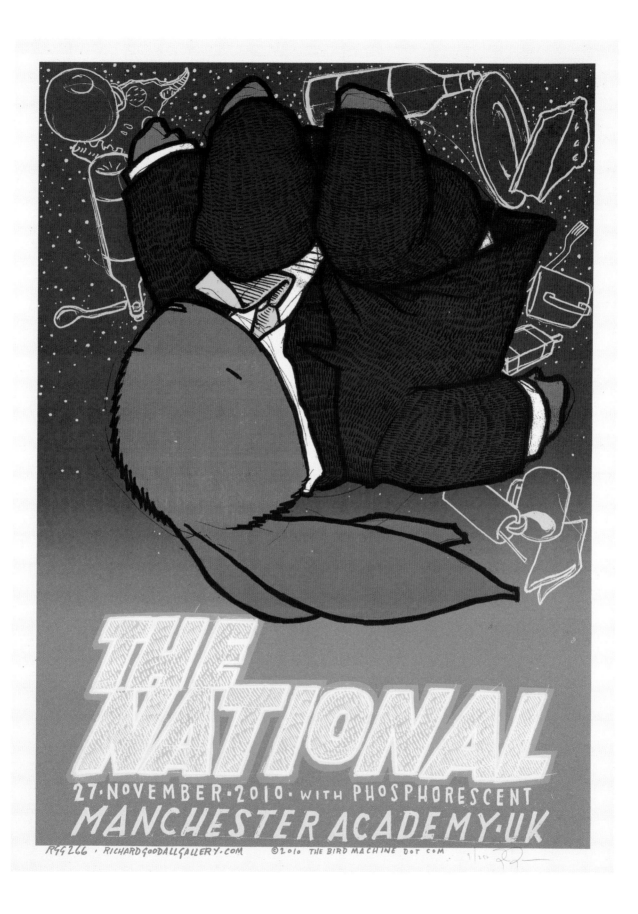

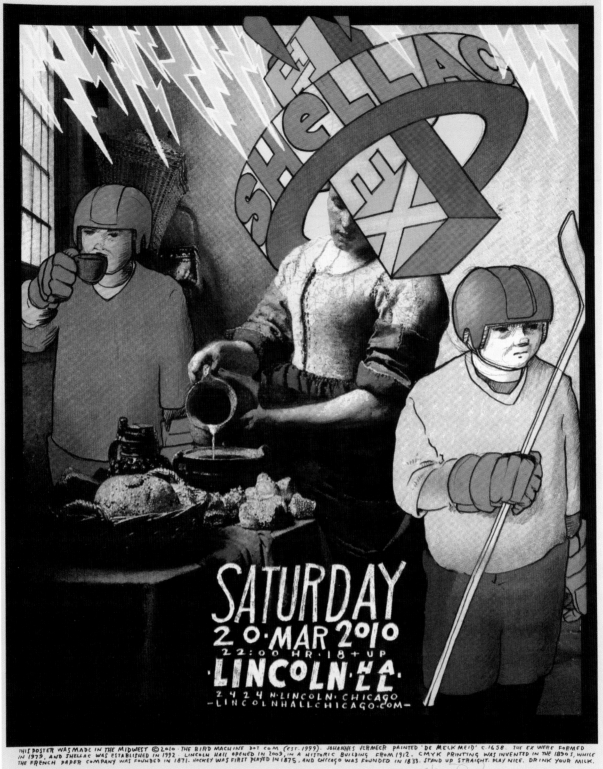

THIS POSTER WAS MADE IN THE MIDWEST © 2010 · THE BIRD MACHINE DOT COM (EST. 1999). JOHANNES VERMEER PAINTED 'DE MELKMEID' c. 1658. THE EX WERE FORMED IN 1979, AND SHELLAC WAS ESTABLISHED IN 1992. LINCOLN HALL OPENED IN 2009, IN A HISTORIC BUILDING FROM 1912. CMYK PRINTING WAS INVENTED IN THE 1890'S, WHILE THE FRENCH PAPER COMPANY WAS FOUNDED IN 1871. HOCKEY WAS FIRST PLAYED IN 1875, AND CHICAGO WAS FOUNDED IN 1833. STAND UP STRAIGHT. PLAY NICE. DRINK YOUR MILK.

Shellac and The Ex (opposite)
2010
Six screens
18 x 24 inches

My first foray into CMYK print-
ing, with all the little tiny dots,
plus a white underprint and an
extra layer of black. Steve Albini
from Shellac suggested that the
poster should depict a hockey
game between the bands, but
in the style of Johannes Ver-
meer (Dutch, 1632–75). I was
flummoxed for a bit, unsure
that I could replicate the style

of an old master, especially
using the limited toolbox of
screenprinting, but eventually
decided to just insert some
hockey players into Vermeer's
masterpiece *The Milkmaid*,
which I doubt was the effect
Steve had originally been
looking for. Bobby Dixon spent
a good amount of time with
me on the phone late at night,
detailing the minutiae of CMYK
for beginners. As I type this
now, five and a half years later,
my monitor is still calibrated for
this particular poster.

The Delicate (bottom)
2011
Four screens
12.5 x 19 inches

Made for the second *Powerful
Prints / Powerful Humans*
portfolio, benefiting our beloved
friend, the late Jason Noble.

Take Time (opposite)
2013
Five screens
18 x 24 inches

Print made for Art Crank
Chicago, a show of bike-themed
screenprints. These films were
assembled from scraps and
were cut spontaneously during
the printing process.

Night Splitting
2015
Six screens
18 x 24 inches

Wood splits best in the winter, but
it's more fun to be out back split-
ting during summer evenings.

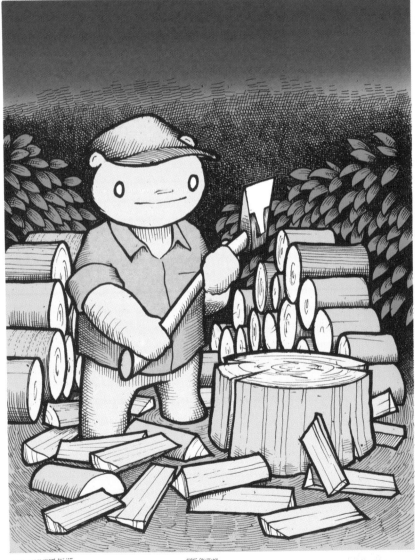

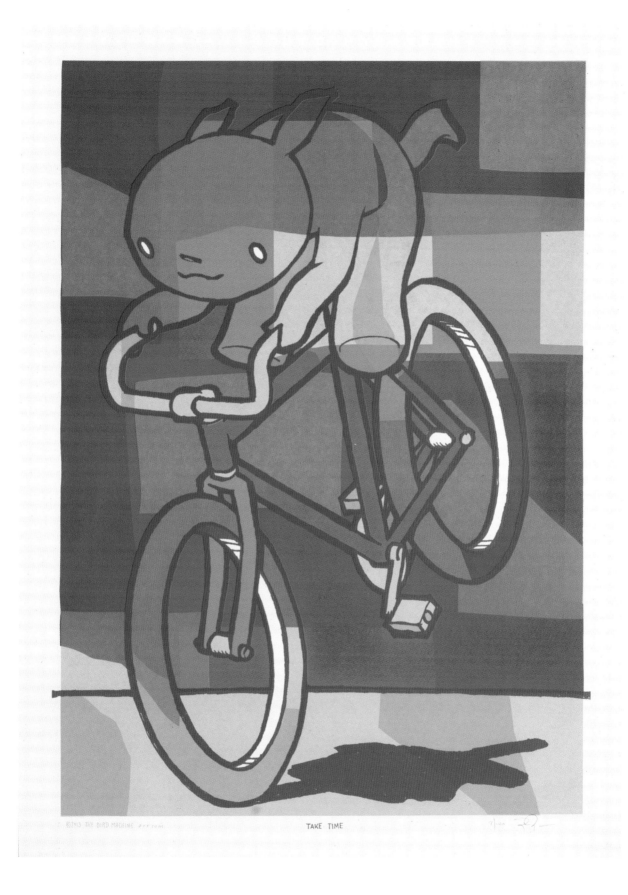

TAKE TIME

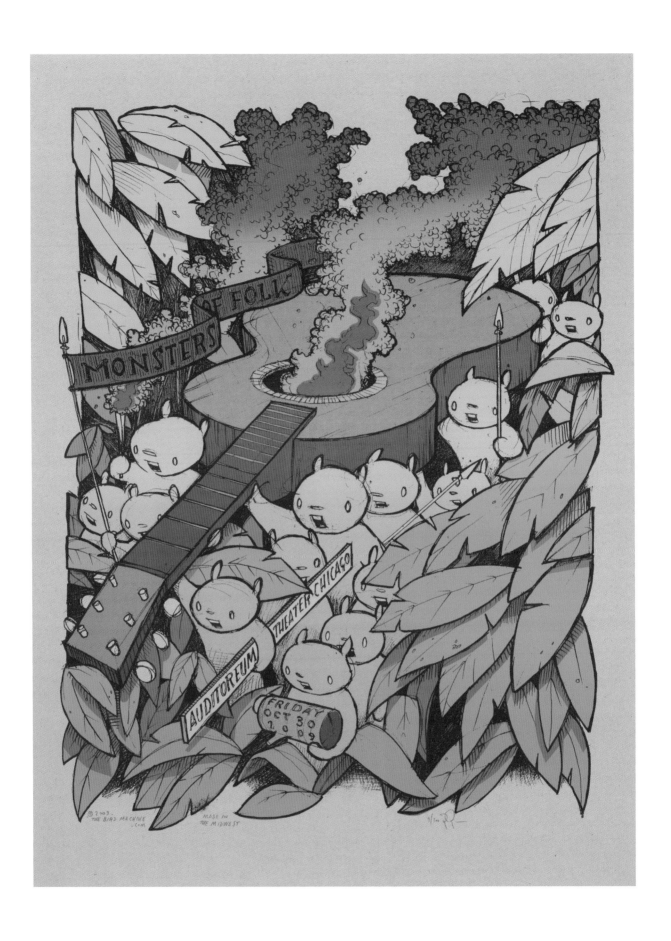

**Monsters of Folk
(opposite)**
2009
Seven screens
18 x 24 inches

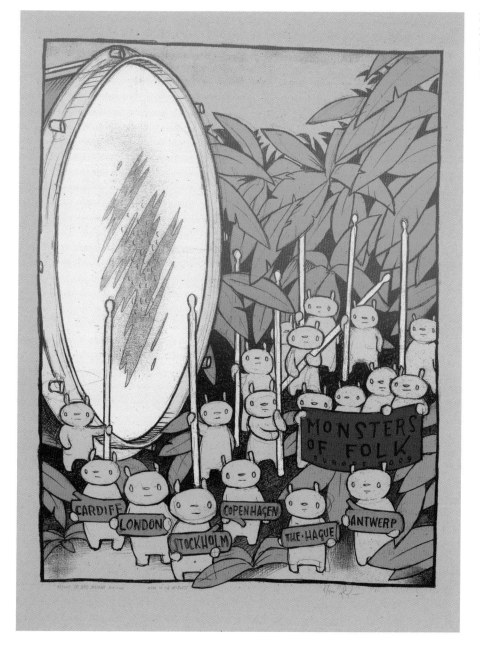

**Monsters of Folk
European Tour**
2009
Five screens
18 x 24 inches

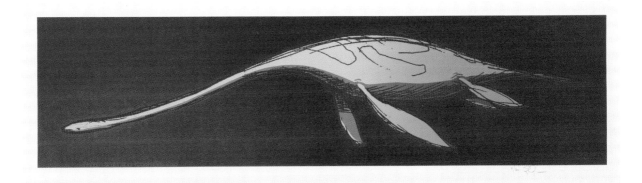

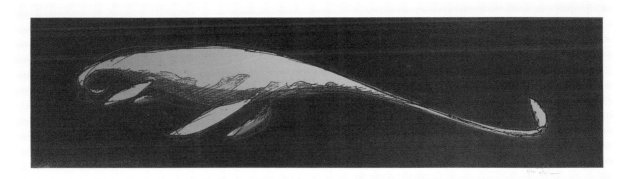

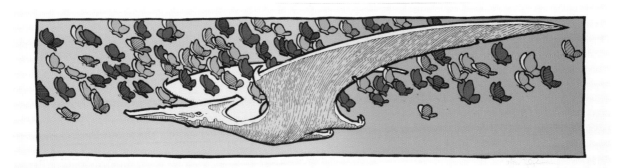

Elasmosaurus Diptych (top)

2009

Three screens per print

Each 8.5 x 28.5 inches

The elasmosauridae were large swimming reptiles, but were plesiosaurs, not dinosaurs. I actually drew these on a plane, which is difficult for me.

The Rabble (bottom)

2013

Five screens

8 x 28 inches

Proportions can be an issue for an illustrator. The shape of this paper seemed to be one of the few places I could easily place a pteranodon. *Rabble* is one of the terms describing a group of butterflies.

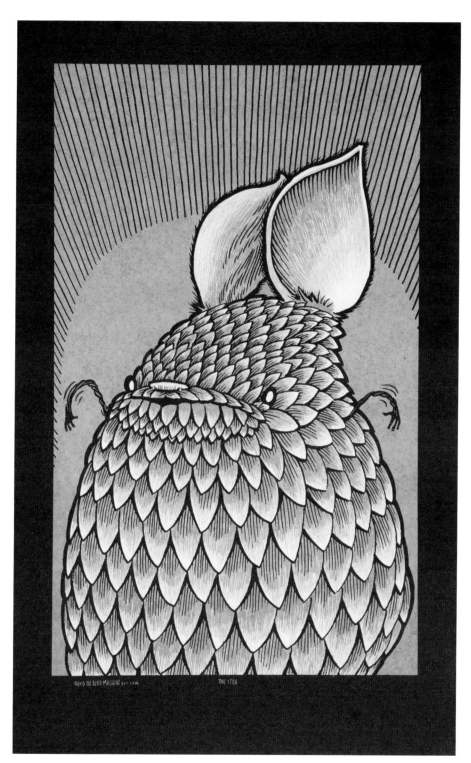

The Itch
2012
Three screens
14 x 22 inches

This was my last print of 2012, made using a small stack of leftover black paper. I drew black pencil lines on white paper, as usual, but then inverted the drawing in Photoshop before kicking out a film positive for printing. This first layer was printed in a transparent white ink. I then hacked at the film with my X-Acto knife, removing some of the print areas, and reburned the film and printed a second layer, again using transparent white ink. I scraped away at the film a second time, and printed a third layer of the same transparent white, which appears as the brightest areas on the print.

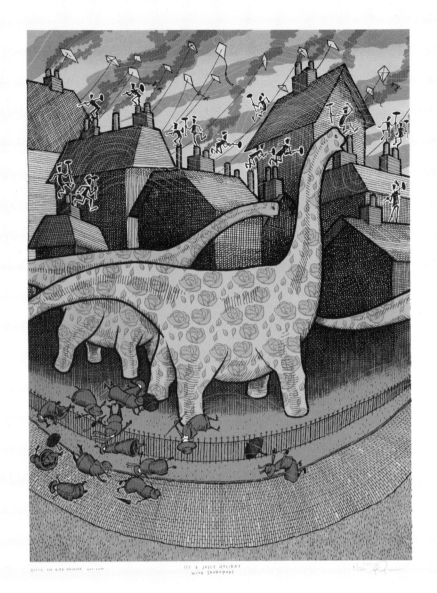

It's a Jolly Holiday with Sauropods

2014
Ten screens
18 x 24 inches

I was involved in a large group of prints being made for a movie company. I was making a poster for a favorite film which had chimney sweeps and kites and nannies being blown away by sudden gusts of wind. Long story short: my poster (and several others) were cut out of the project due to schedule. I took the movie title out of the poster and added a trio of brachiosaurus, and now it truly is a jolly holiday.

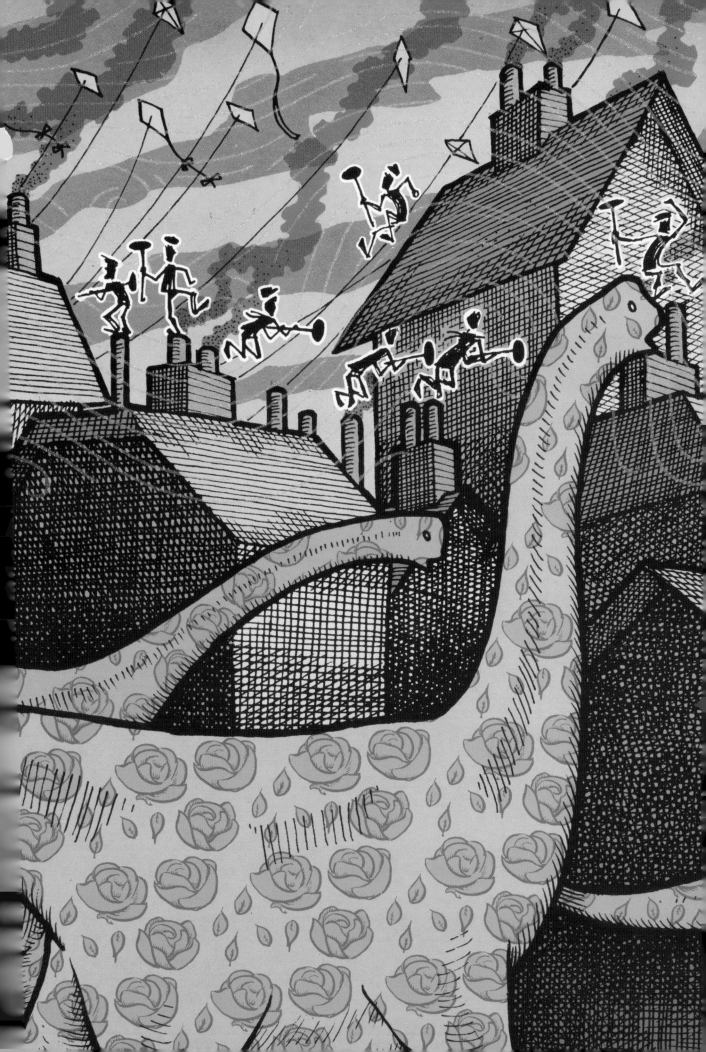

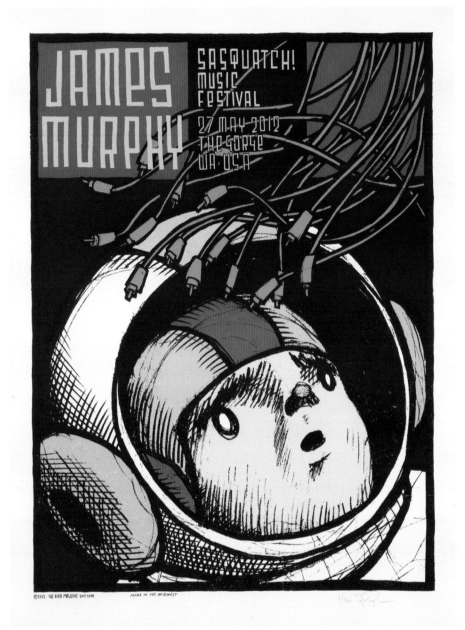

James Murphy at Sasquatch! Music Festival
2012
Five screens
18 x 24 inches

When e-mailing with James Murphy to get permission to do this print (commissioned by the Sasquatch! Music Festival organizers), he confused me with the singer from the band Six Finger Satellite, which hasn't happened in a while. James referred to me as the Other Jay Ryan, which will be my title on my next business cards.

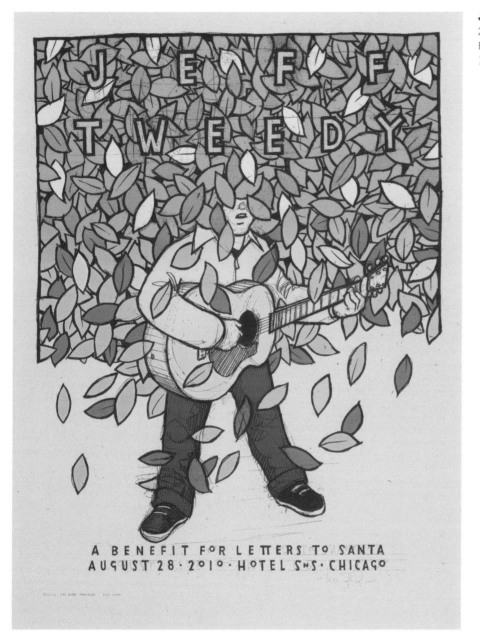

Jeff Tweedy
2010
Four screens
18 x 24 inches

Tiny Herds
2011
Three screens each
Each 9 x 9 inches

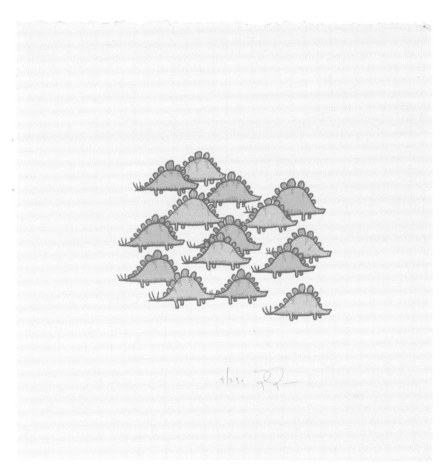

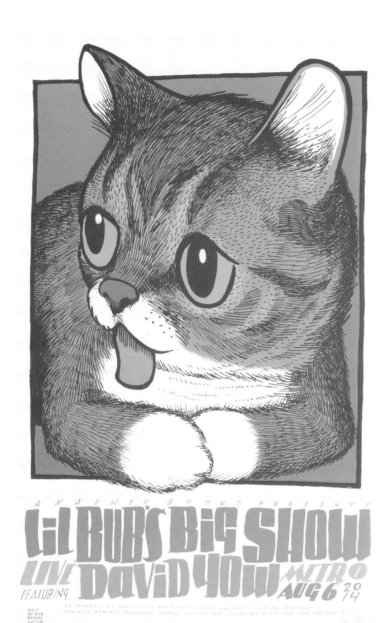

**Lil Bub's Big Show Live,
Featuring David Yow**
2014
Six screens
18 x 24 inches

Everyone's favorite Internet cat held a live party at the Metro in Chicago, and was interviewed by actor/artist/singer David Yow.

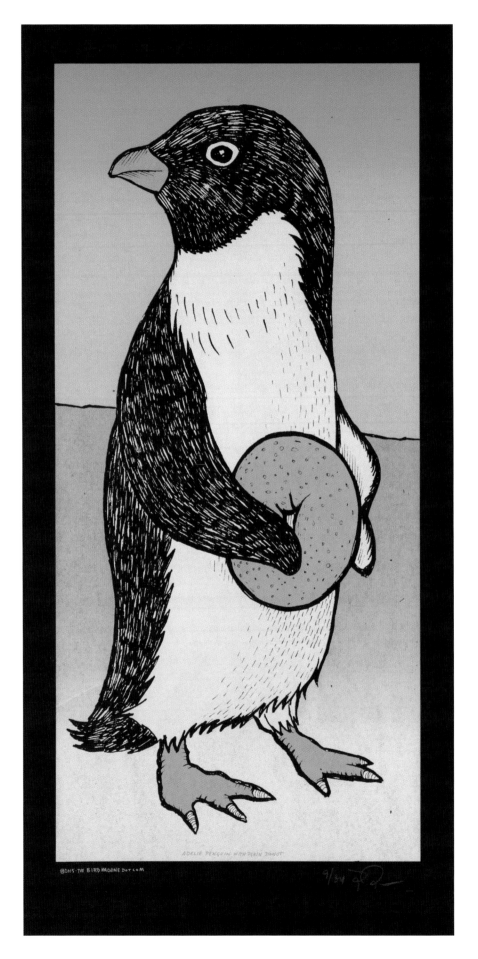

Adelie Penguin with Plain Donut
2015
Four screens
12 x 24 inches

Unbeknownst to me, this print accidentally went online on National Doughnut Day.

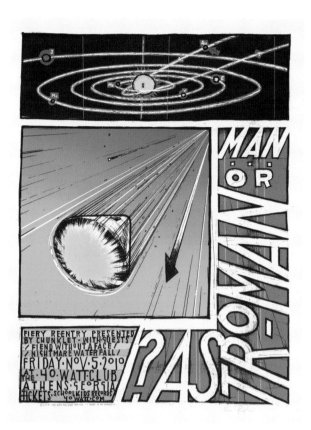

Man . . . or Astro-Man?
2010
Five screens
18 x 24 inches

This is my diagram explaining the gap between appearances by the band. Their highly elliptical orbit just took them too far away from Earth for a little while.

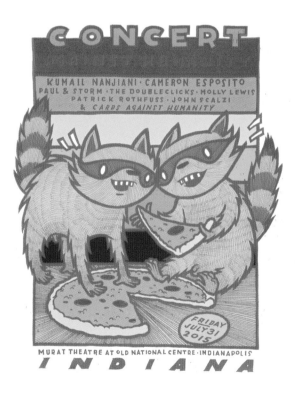

Concert Against Humanity
2015
Five screens
18 x 24 inches

This concert happened in Indianapolis to benefit work against discriminatory legislation passed in the state of Indiana.

Leave Me Alone
2010
Seven screens
18 x 24 inches

Profits from the sale of this print
were sent to Pangeaseed, a
group working in Tokyo to raise
awareness of the cruelty of the
practice of shark-finning.

**The Squadron on Patrol
(opposite)**
2009
Seven screens
26 x 40 inches

Made with graduate print
students at Northern Illinois
University in DeKalb.

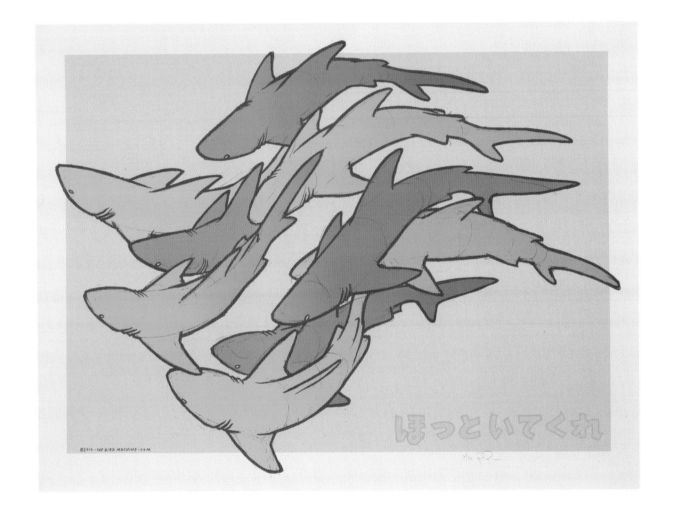

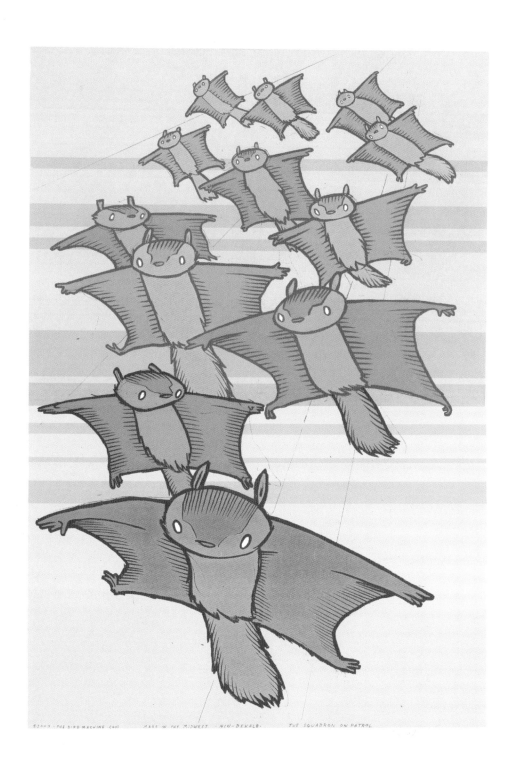

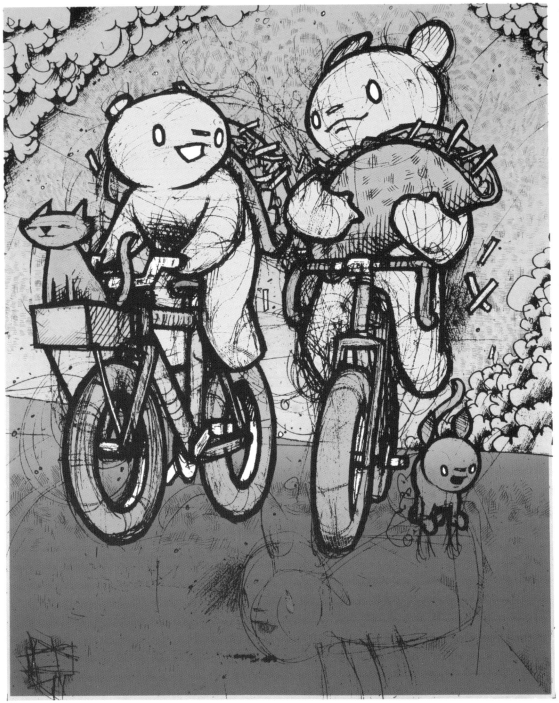

NO MORE DISAGREEMENTS TODAY

No More Disagreements Today (opposite)
2015
Four screens
18 x 24 inches

The cyclist on the left sat on my desk for weeks, sans taco, until I found out who he was with, and what they were doing. Once they had a mission, everyone got along.

The Iron Giant **(bottom)**
2014
Six screens
18 x 24 inches

Official print celebrating Brad Bird's 1999 animated film, commissioned through Mondo.

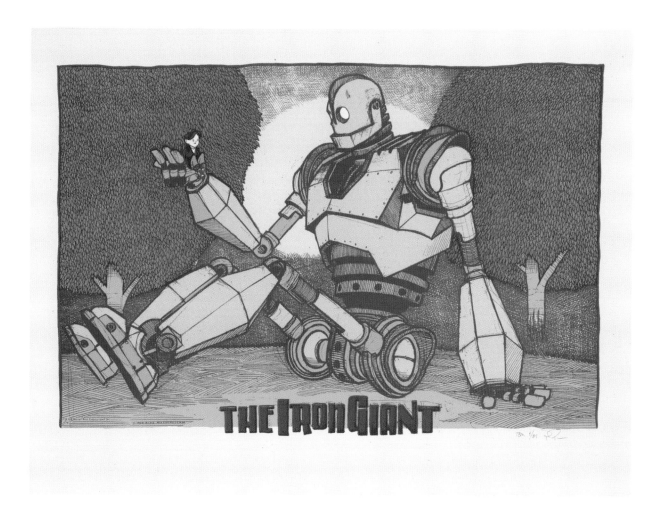

Ten Banthas

2010
Six screens
18 x 24 inches

Moisture vaporator and wildlife under the busy skies of Tatooine. One of several official Lucasfilm-sanctioned prints promoting 2010 screenings of the original three *Star Wars* movies at the Alamo Drafthouse Cinema in Austin, Texas. Curated by Mondo. Printed at D&L Screenprinting in Seattle. ©2010 Lucasfilm Ltd. & TM. All rights reserved. Included with permission.

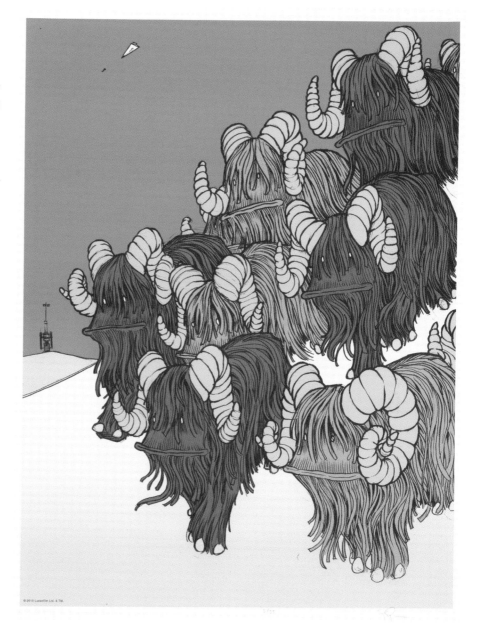

Mr. Wu's Pigs (bottom)
2010
Five screens
18 x 24 inches

Aesthetic Apparatus in
Minneapolis arranged a gallery
show of printmakers working
on the theme of the late, great
Deadwood TV series. These are
Mr. Wu's pigs, who keep the
camp clean.

Be Alert (opposite)
2010
Five screens
18 x 24 inches

Seth, our beloved greyhound
(1999–2010), and a couple of
his compatriots have paused to
consider their surroundings.

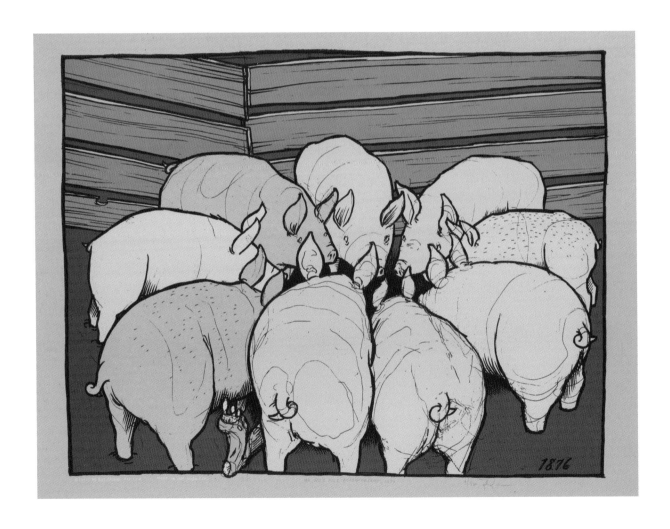

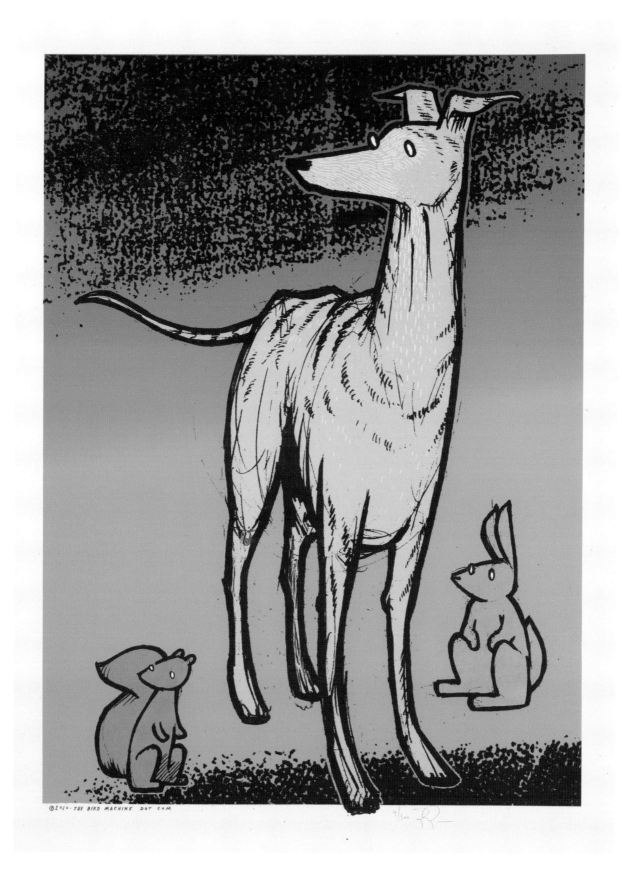

NOT TO DO THIS

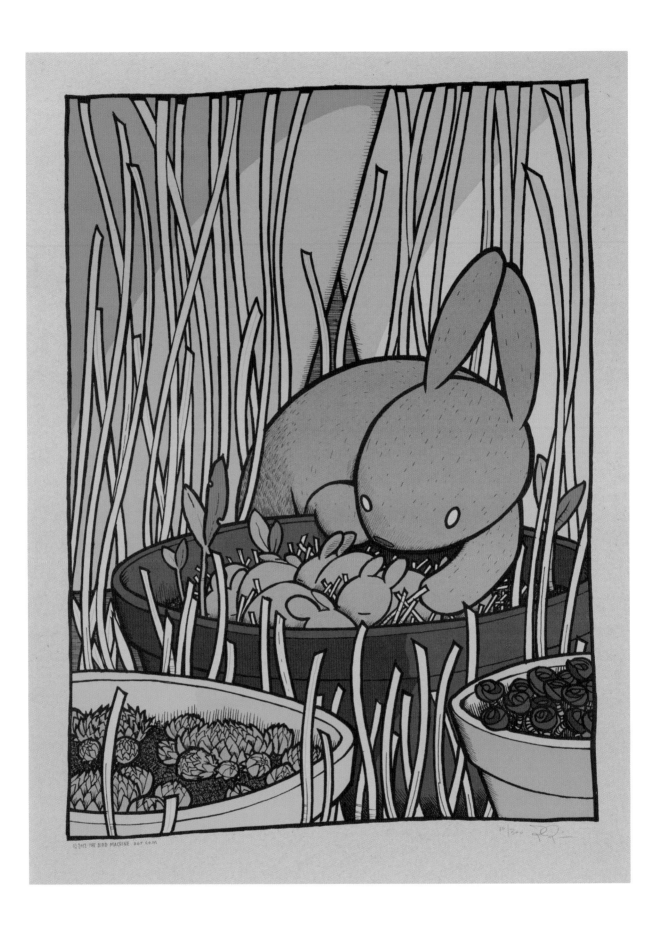

NO ONE TOLD ME

Clever Girl (opposite)
2012
Eight screens
18 x 24 inches

Despite the fact that the print
shop is at least a block away
from any substantial green
space, a mother rabbit chose
one of our flowerpots as a good
place to dig a nest to fill with
her babies. She has returned
to birth multiple litters on the
paved slab behind our shop.

Sloth Comes to Visit
Collaboration with
Luke Drozd
2012
Eight screens
18 x 24 inches

One of my very favorite
Londoners, Luke Drozd, came
to visit en route to Austin, Texas
for a Flatstock convention. We
e-mailed some elements back
and forth, and then worked
intensely for two days to get
these prints finished. We were
both confused and delighted by
the way this turned out.

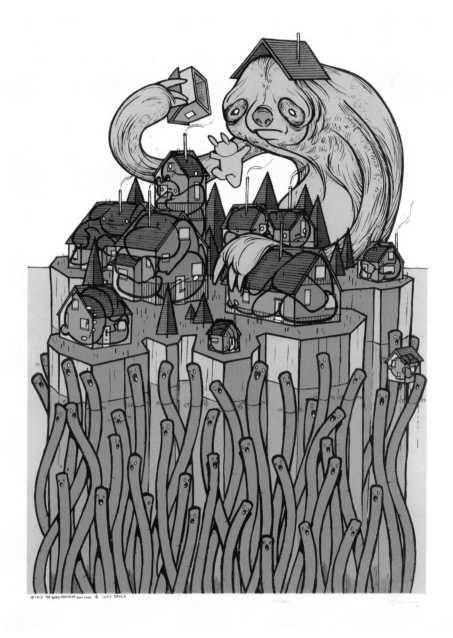

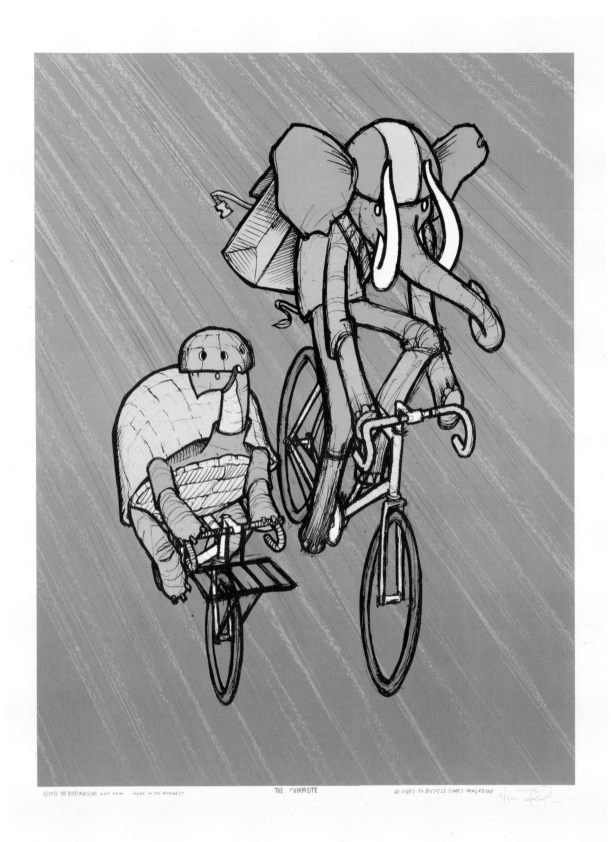

THE COMMUTE

HI-FIVES TO BICYCLE TIMES MAGAZINE

The Commute (opposite)
2012
Eight screens
18 x 24 inches

This image was originally made for the cover of *Bicycle Times Magazine* (see also p. 73).

Nine Black Puppies
2015
Four screens
18 x 24 inches

Started drawing puppies. Ended up with eight of them. Realized I could reference the title of an album by the Mountain Goats, so I added one more puppy.

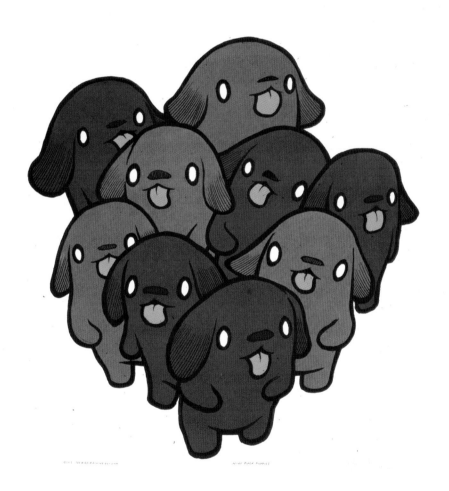

Cargo Flip
2010
Six screens
12.5 x 19 inches

My contribution to Poster
Cabaret's "Bike Prints" series.
This was made while my
beloved Cetma cargo bike was
being welded together, and I
was looking forward to all the
good times we would soon be
having out in the world.

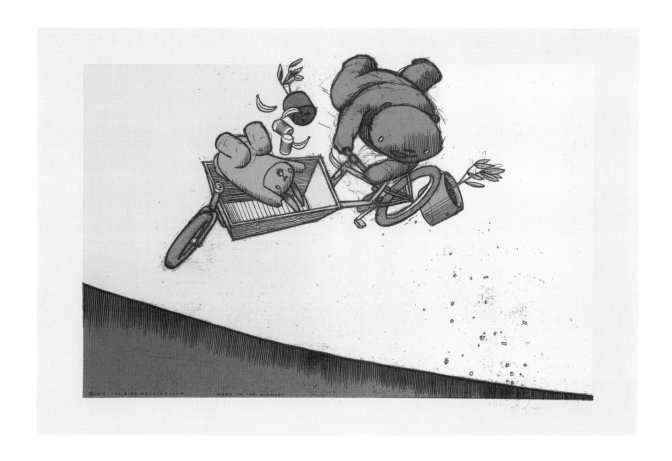

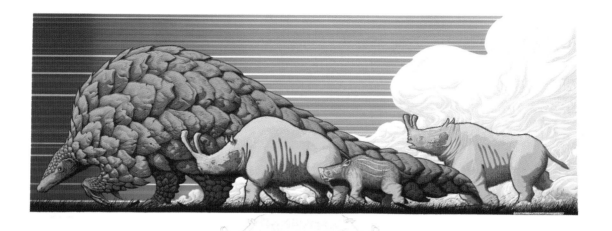

Versus
Collaboration with
Aaron Horkey
2010
Twenty-five screens
12.875 x 29.75 inches

Remarqued print depicted. As Aaron notes in the foreword to this book, this was our first time working together. After initial drawings, we literally pushed paper back and forth across the kitchen table. Thankfully, Aaron was rather nocturnal while I was a morning person, so he could work until three a.m. and I could start my turn at six a.m. We spent twelve days working on this, each learning about how the other one plans drawings. Aaron is a ridiculously hard worker and has a masterful under-standing of how shading works on flat depictions of three-dimensional shapes. His line work is impeccable and he's fun to be around, so this project went swimmingly. We printed three different editions at once, including one set for my subscribers (different paper), one "remarqued" set upon which we planned some hand embellishment (pictured), and a "standard" edition. This was one of the landmark projects in my life, and I was thankful to get to work on it. The image depicts a giant pangolin, two adult brontothe-rium, and a brontotherium calf in front of a billowing cloud of dust. In the end, we printed twenty-five screens:

1. sky/stripes
2. sky/stripes
3. background light blue cloud flood
4. brontotherium yellow flood
5. background cloud blue shadow
6. pangolin orange flood
7. brontotherium shadow texture
8. pangolin shadow
9. gray foreground cloud flood
10. sky trans overprint
11. lighter gray foregound cloud shadow
12. brontotherium shadow flood
13. brontotherium highlight flood
14. brontotherium highlight texture
15. background cloud highlight
16. tongues
17. pangolin highlight flood
18. pangolin highlight texture
19. background cloud second highlight
20. highlight foreground dust
21. key plate background cloud
22. key plate pangolin
23. key plate foreground cloud
24. key plate brontotherium & grass
25. key plate dark shadows & grass

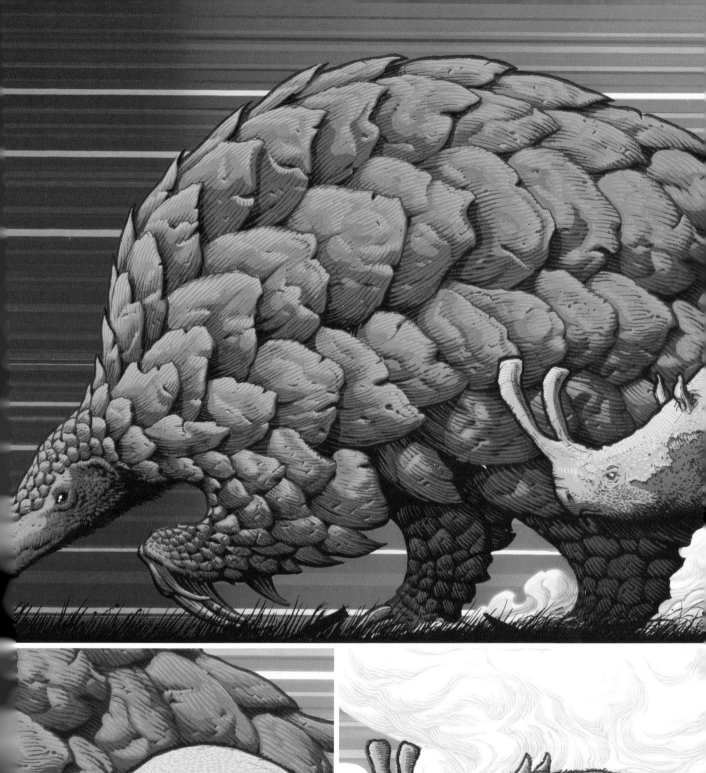
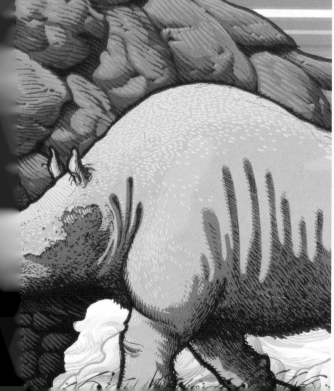
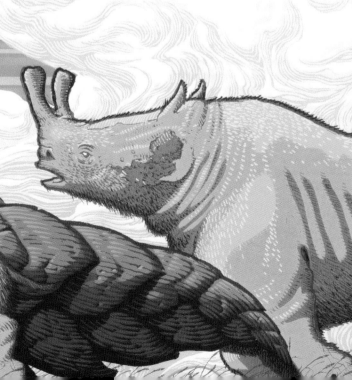

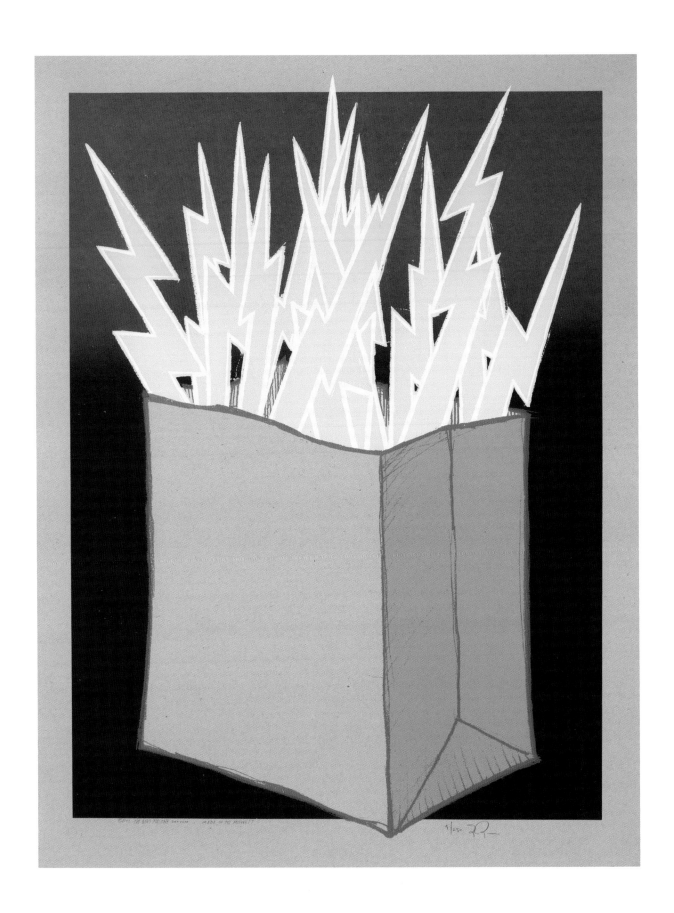

Bag of Lightning
2009
Six screens
20 x 26 inches

Sometimes, if we have extra
lightning laying around, we just
bag it up and take it with us.

434344
2014
Four screens
8 x 10 inches

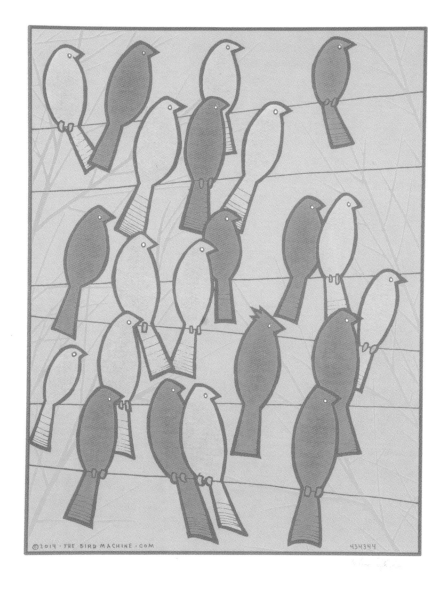

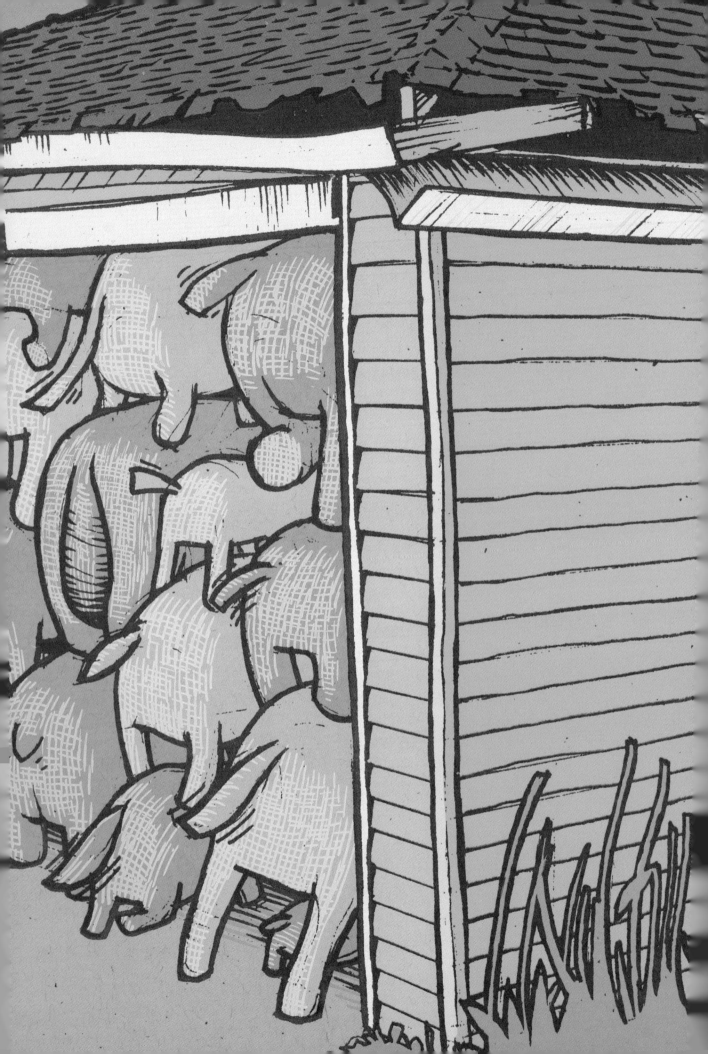

The Garage Suite

In 2011 and 2012, we made a series of prints about the ramshackle garage behind my house. The structure wasn't built correctly when it was put up in 1960, and fifty years later it was barely holding together. One wall fell off the foundation when a neighbor tapped it with his bumper. There was a hole in the roof. Squirrels and cats came and went freely. I wanted to celebrate the good times we'd had together before the garage was reduced to moldy splinters, and these eight moments are an excellent summary of our relationship.

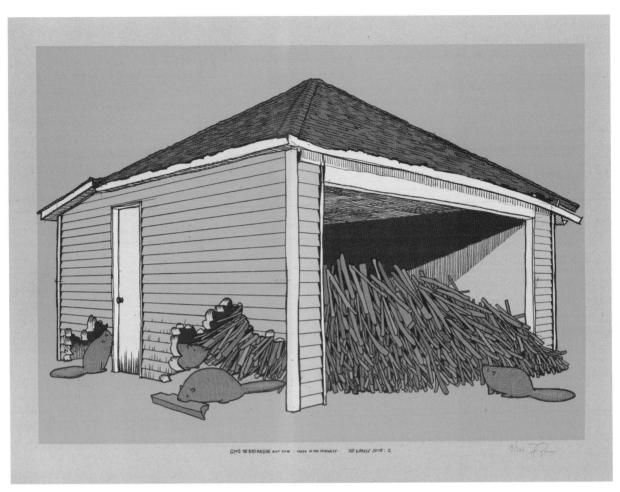

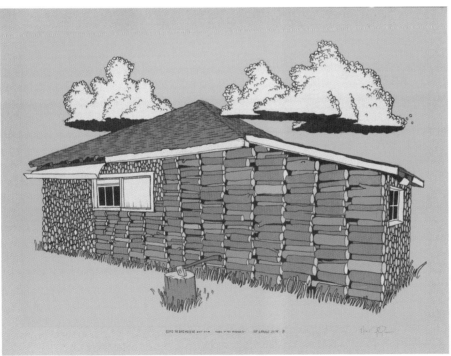

C [beaver infestation] (top)
2012
Six screens
18 x 24 inches

B [firewood, low skies] (bottom)
2012
Six screens
18 x 24 inches

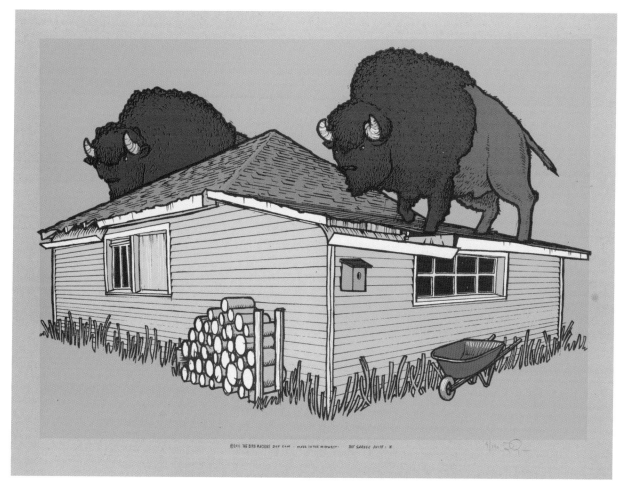

E [roof bison] (top)
2011
Six screens
18 x 24 inches

**F [trees, rabbits]
(bottom)**
2012
Six screens
18 x 24 inches

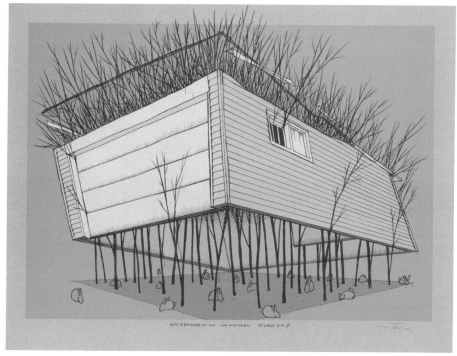

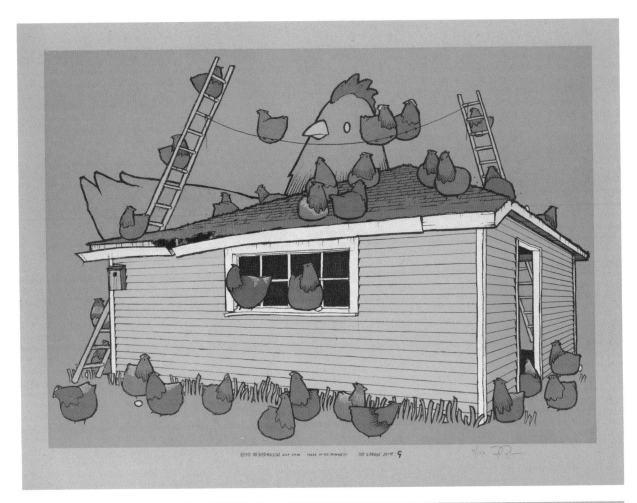

G [chickens] (top)
2012
Six screens
18 x 24 inches

H [gorilla mechanics, large bikes] (bottom)
2012
Six screens
18 x 24 inches

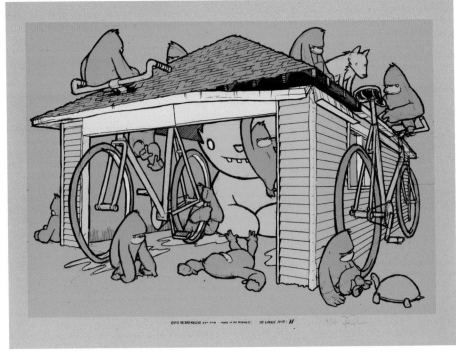

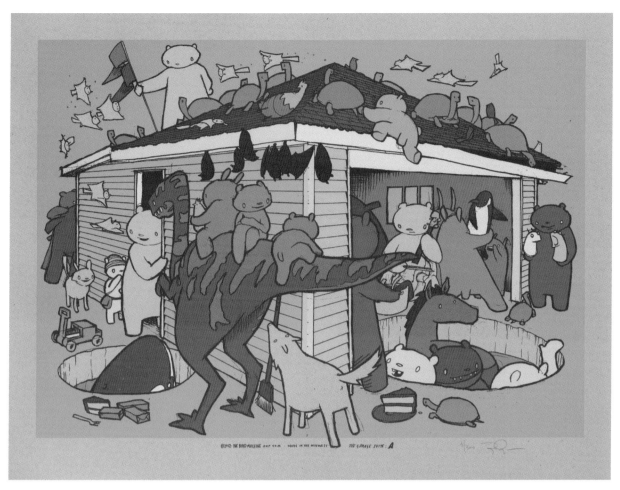

A [that one party]
(top)
2012
Seven screens
18 x 24 inches

D [animals, stuffed]
(bottom)
2011
Seven screens
18 x 24 inches

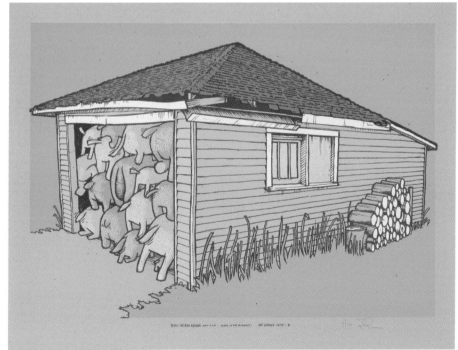

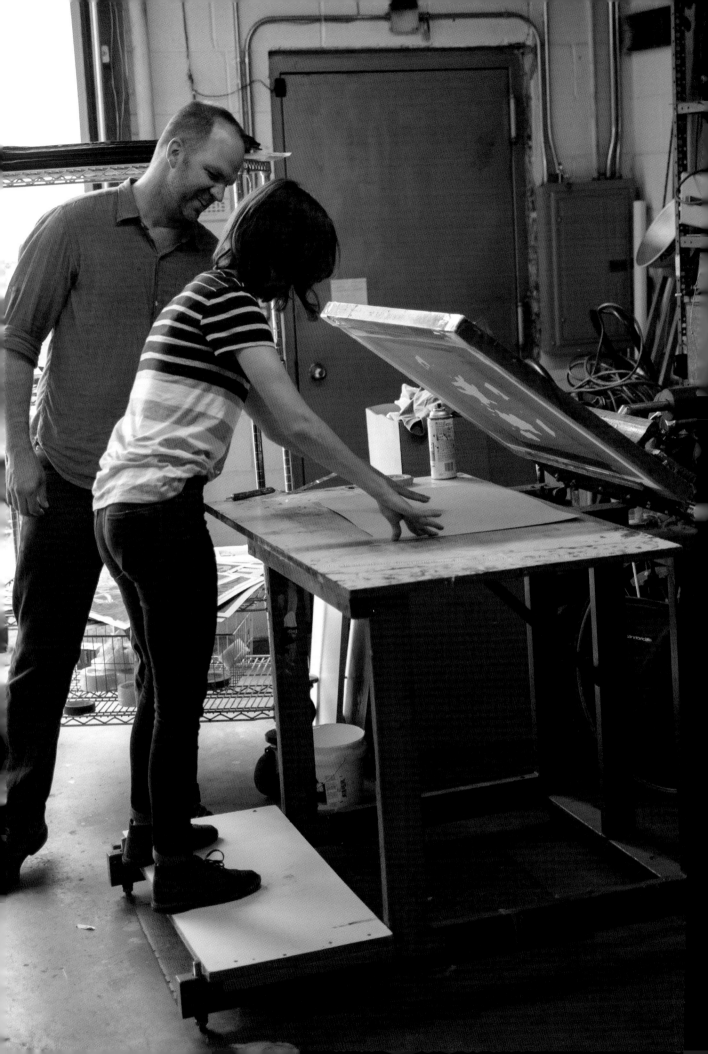

Workshop Prints

This series was motivated by an urge to teach how and why we make this work. I have always felt that an educated audience is the best audience, and I believe that the ideal classroom is my own shop. I enjoy the variables and surprises which arise to challenge me every time we run a workshop. We bring in ten guests for six hours on a Saturday. I will have made a drawing ahead of time, and we've got the shop set up like a cooking show, with everything prepped so that we can get a lot of work done quickly. Over six hours, we run through cutting films by hand, mixing ink, and printing four screens (both by hand and on the semiauto press) onto a hundred sheets of paper. By the end of the day, everyone leaves with a signed and numbered screenprint which they have had a hand in making.

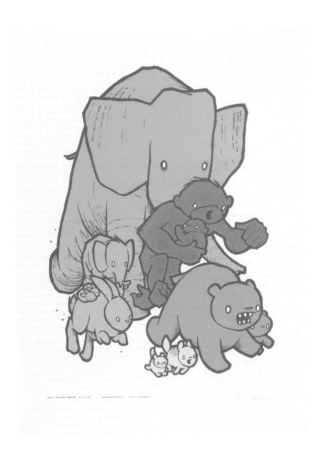

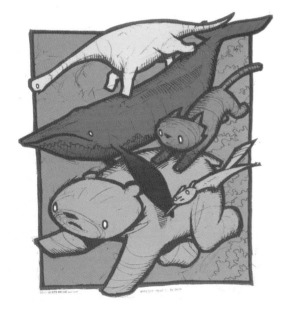

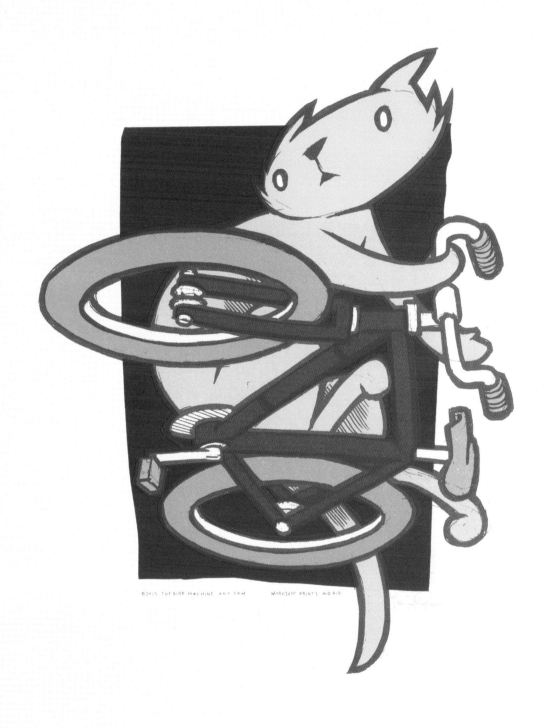

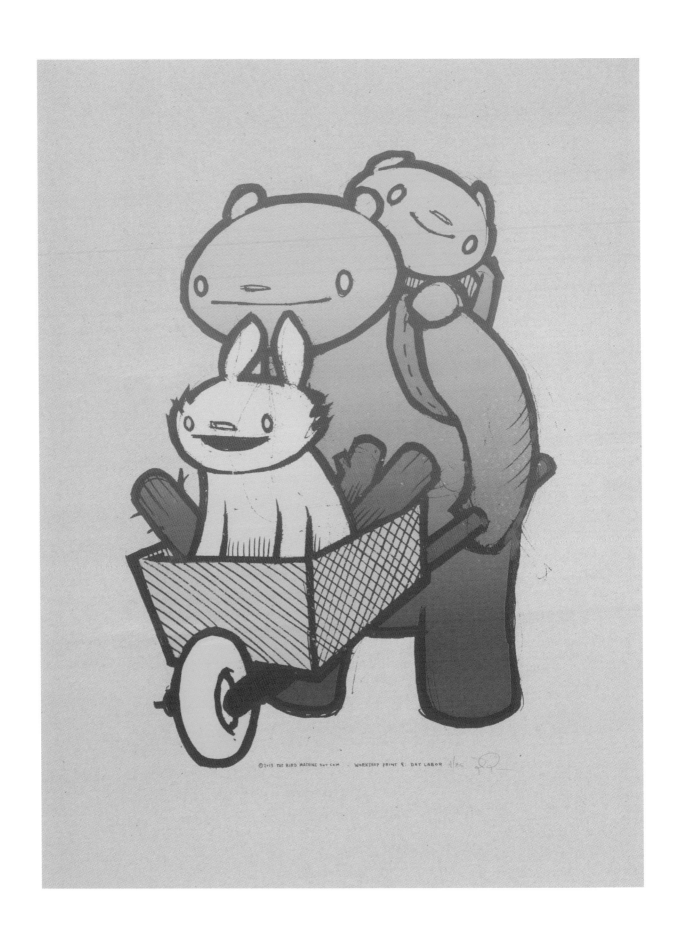

©2013 THE BIRD MACHINE dot com WORKSHOP PRINT N: DAY LABOR 11/25

4. Day Labor (opposite)
2013
Four screens
18 x 24 inches

5. Welcome
2013
Four screens
18 x 24 inches

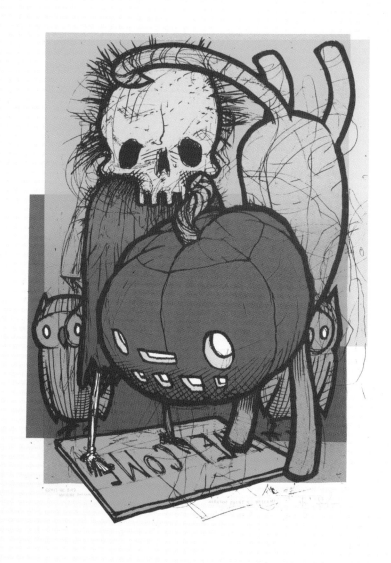

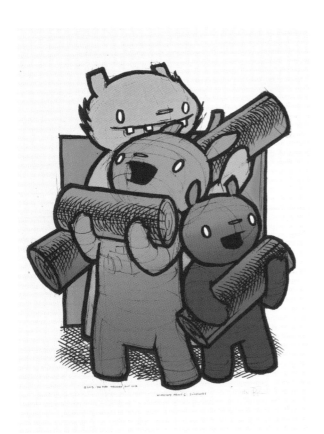

6. Souvenirs (top left)
2013
Five screens
18 x 24 inches

7. Pursuit (top right)
2013
Four screens
18 x 24 inches

**8. Family Crest
(lower right)**
2014
Four screens
18 x 24 inches

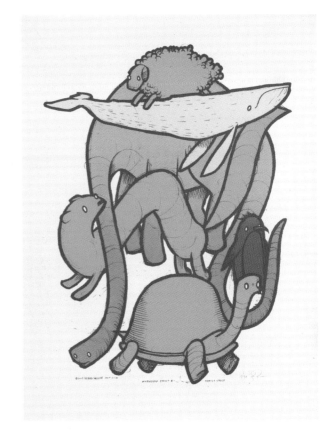

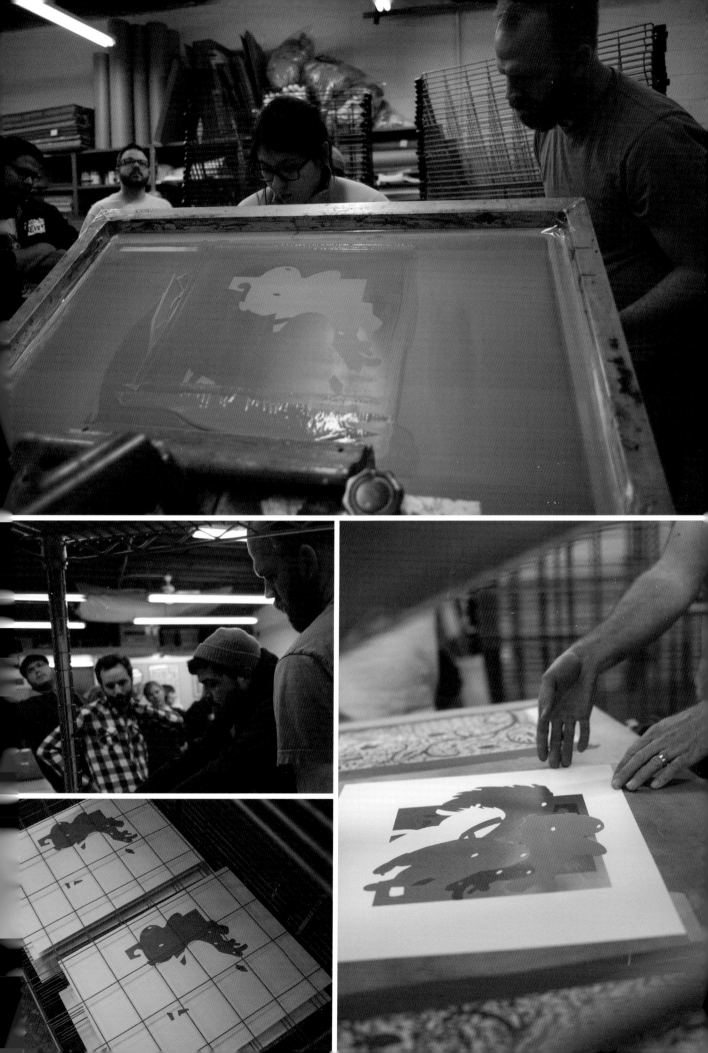

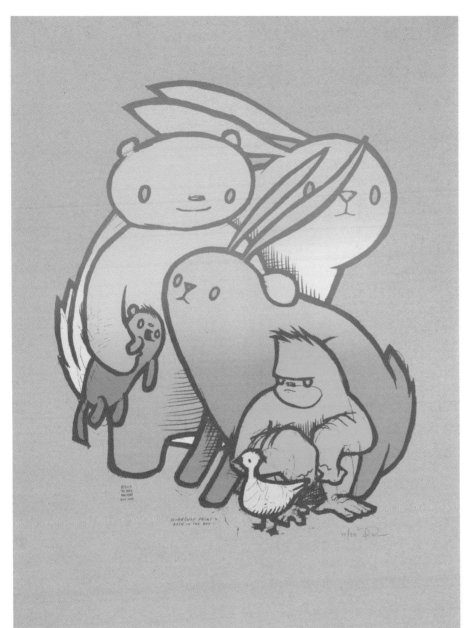

10. Turning
2014
Four screens
18 x 24 inches

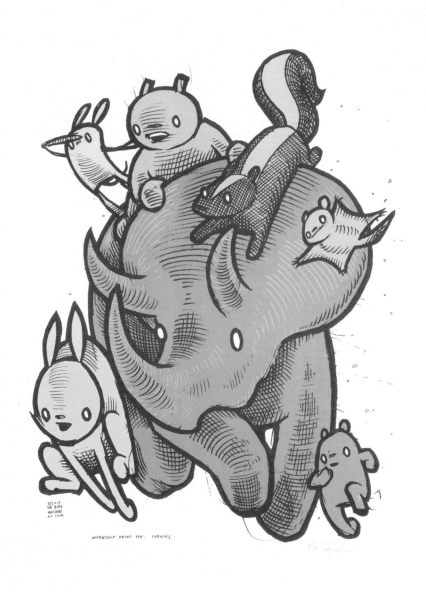

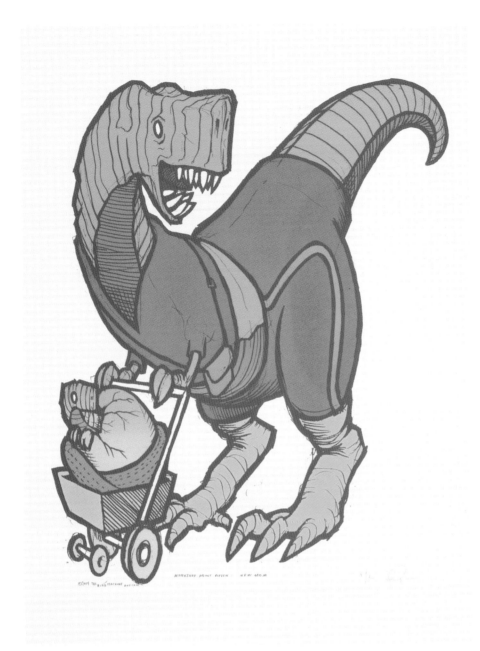

11. New Mom
2014
Four screens
18 x 24 inches

**12. Ouroboros
(opposite)**
Collaboration with
Aaron Horkey
2014
Four screens
18 x 24 inches

Aaron dropped in to help run
this print during the workshop.
He is not used to working
publicly in the way that these
workshops require, and it was a
pleasure to see him operate so
openly and generously with our
guest printers.

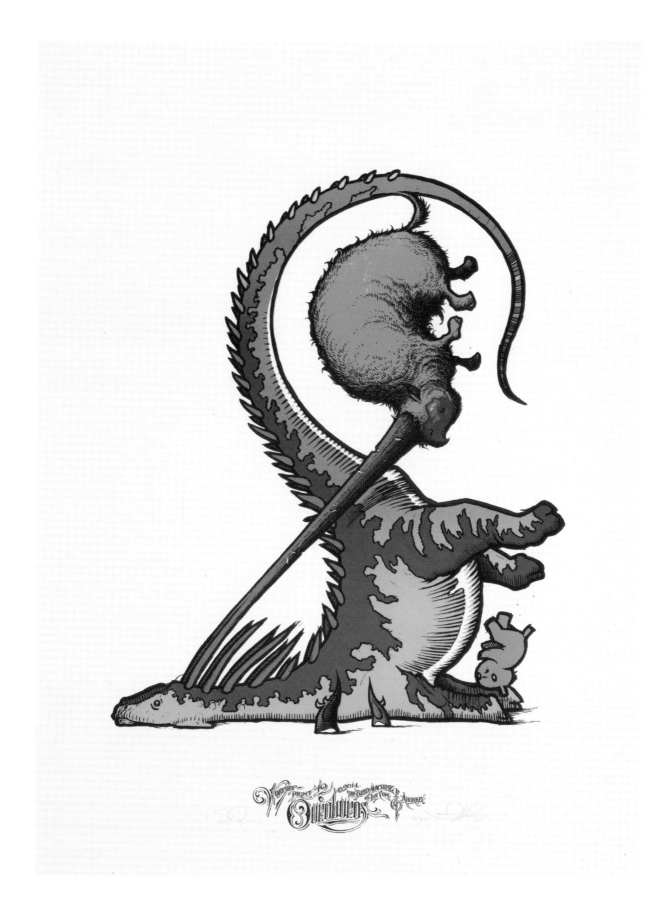

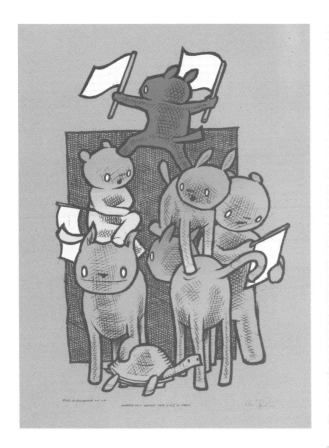

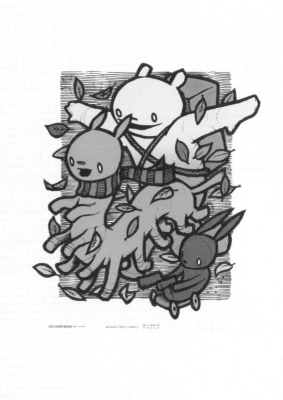

13. There Is No "I" in Turtle (top left)
2014
Four screens
18 x 24 inches

14. Beginning of the End (top right)
2014
Four screens
18 x 24 inches

15. Ride Share (bottom right)
2014
Four screens
18 x 24 inches

16. When We Had Thumbs (opposite)
2015
Four screens
18 x 24 inches

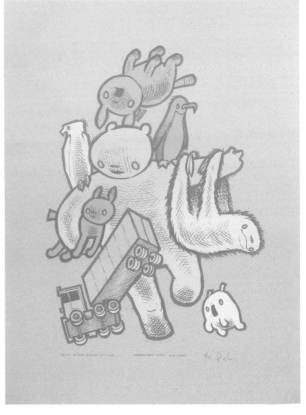

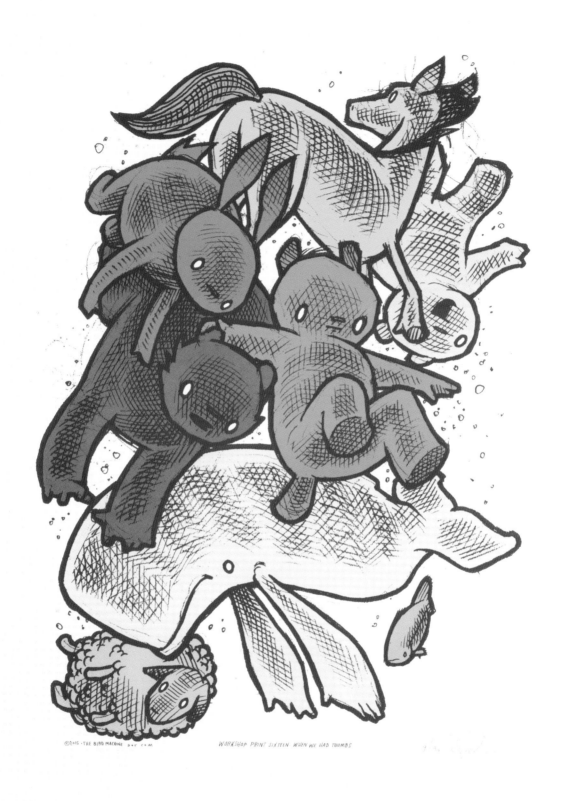

©2015 · THE BIRD MACHINE · bird machine

WORKSHOP PRINT SIXTEEN WHEN WE HAD THUMBS

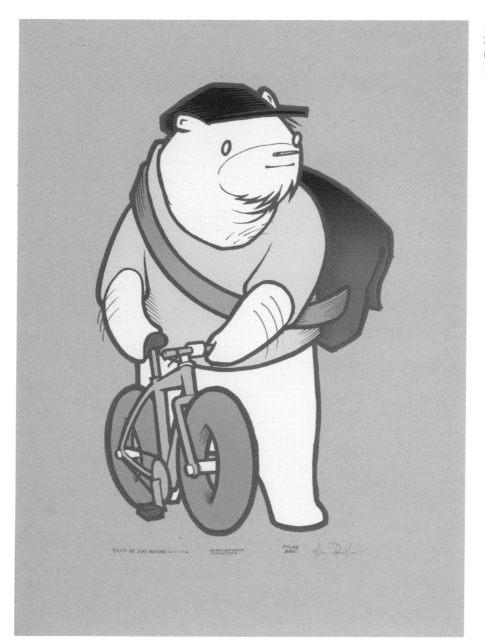

17. Polar Bike
2015
Four screens
18 x 24 inches

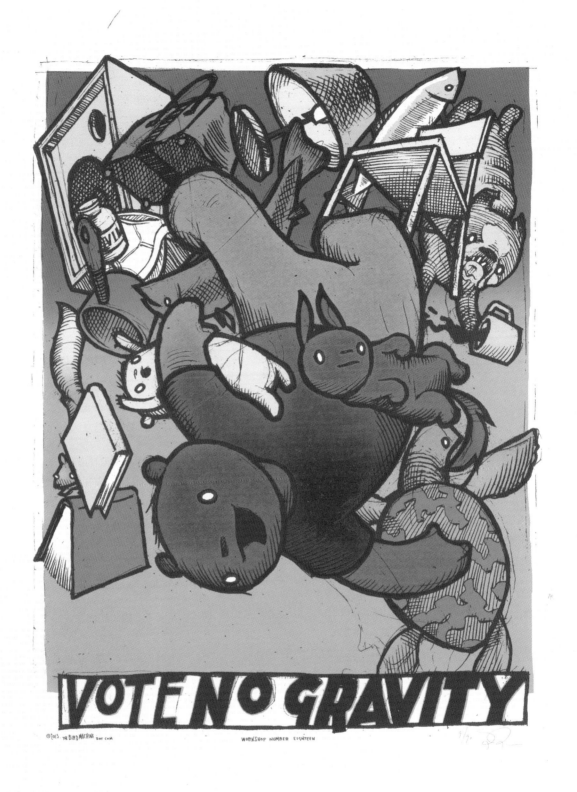

18. Vote No Gravity (opposite)
2015
Seven screens
18 x 24 inches

19. Get Hot
2015
Four screens
18 x 24 inches

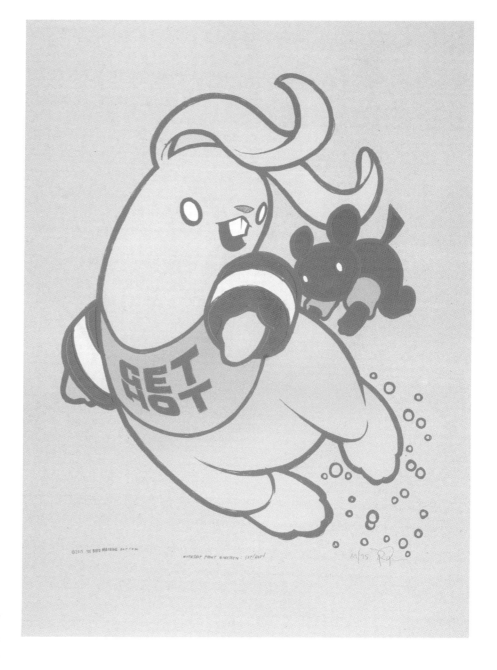

Photo by Sage Perrott, at Penland School of Crafts, August 2014.

Thanks

This book would not have come together without the diligent prodding of Jason Harvey, who handled the volume's layout and was something of a project manager and editor. Nathan Keay at Tiny Mechanism carefully shot all of the photos, except where noted. In the descriptions which accompany the prints, the use of the pronoun "I" doesn't give credit to the people who did a lot of the work. The Bird Machine home team during the period covered in this book included handsome, talented, and capable humans such as Elizabeth Kovach, Michael Lauritano, Will Sturgis, Sara Lee Parker, Ben Chlapek, and Jack Ryan. Assistance was also generously provided on several occasions by Erin Piepergerdes, Ryan Lagasse, John Hastie, Kevin Woosley, Landon Perkins, Sage Perrott, Jarrett Dapier, Andy Yamashiro, Sarah Goone, Zach Visotsky, Andi Wywiorski, Harley Rangel, Scout Shannon, Haven Knight, Michael Vivian, Matthew Barnard, James Ricker, and the late Stephanie Morris. I was honored to get to collaborate directly with Dan Black and Jessica Seamans, Luke Drozd, Dan McCarthy, and Aaron Horkey.

Additional thanks (for extraordinary effort) is owed to Johnny Temple, Johanna Ingalls, Ibrahim Ahmad, and Aaron Petrovich at Akashic Books, Wayne Romano and Mark Billman at APR Graphics, Ben Halperin at Bruce Packaging, Andrea Troolin and Victoria Roe at Ekonomisk, as well as Chris Hohn and Tedra Ashley-W at Lincoln Bookbindery. Expertise, encouragement, and guidance were provided by Geoff Peveto, Justin Jewett, Aaron Nunley, Stephanie Merello, Mitch Putnam, Bobby Dixon, Tony Dreyfuss, Feinkunst Krüger, Richard Goodall Gallery, Mondo, Rotofugi, Gallery 1988, the Cotton Candy Machine, and Dan MacAdam and Mat Daly (who also let me get on their respective presses when mine was broken).

None of this would have happened without Diana Sudyka, my friend who has been drawing across from me at the kitchen table for more than half my life.

Thank you to my parents, who never told me not to do this.

This book is dedicated to Isabel S. Ryan.

Index

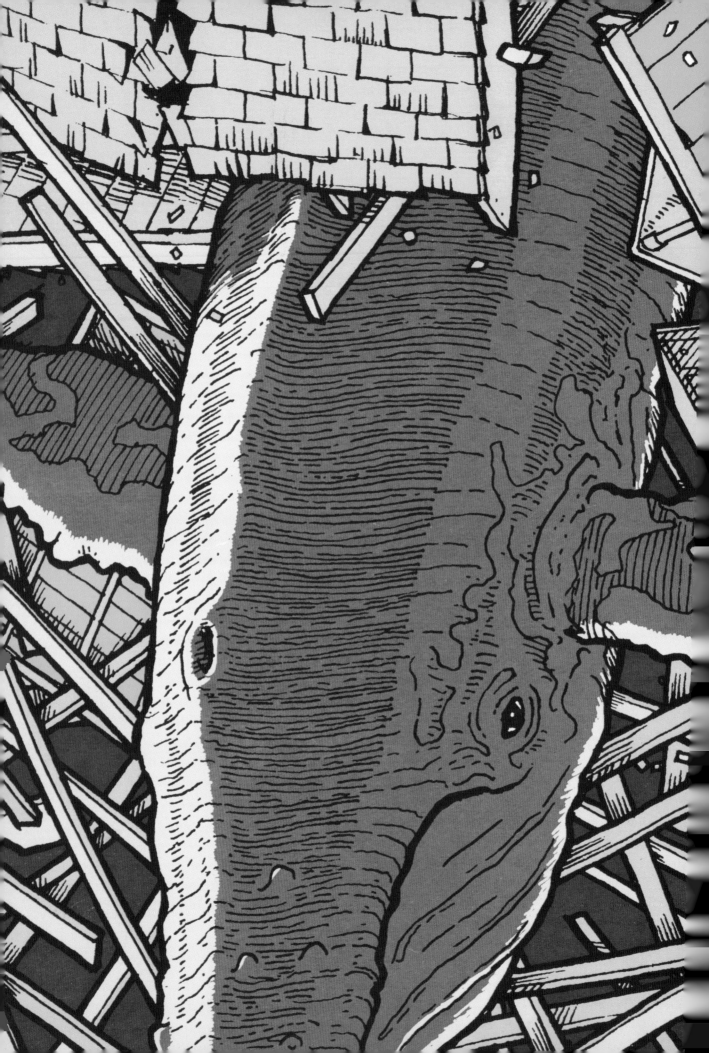